PICTURE PUZZLES
Across America

Play these other fun puzzle books by USA TODAY:

USA TODAY Sudoku
USA TODAY Everyday Sudoku
USA TODAY Crossword
USA TODAY Logic
USA TODAY Sudoku X & Mini Sudoku
USA TODAY Word Roundup & Word Search
USA TODAY Word Play
USA TODAY Jumbo Puzzle Book
USA TODAY Picture Puzzles
USA TODAY Everyday Logic
USA TODAY Jumbo Puzzle Book 2
USA TODAY Txtpert
USA TODAY Don't Quote Me

PICTURE PUZZLES

Across America

**Andrews McMeel
Publishing, LLC**

Kansas City • Sydney • London

Produced by DOWNTOWN BOOKWORKS INC.

President Julie Merberg
Senior Vice President Patty Brown
Puzzle Master Sarah Parvis
Designer Brian Michael Thomas/
 Our Hero Productions
Special Thanks Pam Abrams, Caroline Bronston,
 Jennifer Brown, Jim Kane, Emily Simon

USA TODAY Picture Puzzles Across America copyright © 2010 by
USA TODAY. All rights reserved. Printed in China. No part of this book
may be used or reproduced in any manner whatsoever without written
permission except in the case of reprints in the context of reviews. For
information, write Andrews McMeel Publishing, LLC, an Andrews McMeel
Universal company, 1130 Walnut Street, Kansas City, Missouri 64106.

10 11 12 13 14 WKT 10 9 8 7 6 5 4 3 2 1

ISBN-13: 978-0-7407-9750-7
ISBN-10: 0-7407-9750-6

andrewsmcmeel.com
puzzles.usatoday.com

ATTENTION: SCHOOLS AND BUSINESSES
Andrews McMeel books are available at quantity discounts with bulk
purchase for educational, business, or sales promotional use. For
information, please write to: Special Sales Department, Andrews McMeel
Publishing, LLC, 1130 Walnut Street, Kansas City, Missouri 64106.

INTRODUCTION

Take a photographic road trip across America with the picture puzzle pros at USA TODAY—back again with a new collection of eye-crossing puzzles guaranteed to exercise your gray matter in the most entertaining way possible! Most of the picture puzzles included here are our version of spot-the-difference games. Photo scrambles and "Which picture is different?" puzzles are also included.

A few tips for solving these puzzles: As you compare the two seemingly identical pictures, view each photo as a grid. Start at a corner and compare that section to the section of the opposite picture. Continue working through the pictures section by section, carefully comparing every element. For the scrambles, we'll give you one section for starters. Survey the edges of the starter section, then look among the other sections for the piece that would align on one or more edges. Find that next piece and build from there; you'll be able to solve even the most difficult scrambles.

Good luck!

Easy Riding

Hats Off to You!

Can you spot this brassy dame's costume changes?

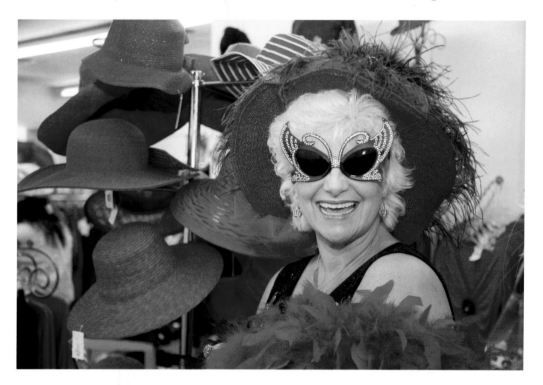

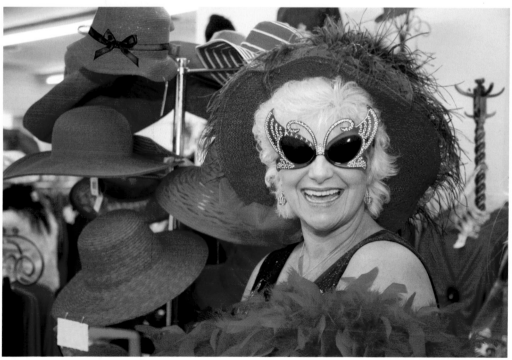

7 Changes

Hang In There

**We played cat and mouse with this pet pic,
but we're sure you can catch all the changes.**

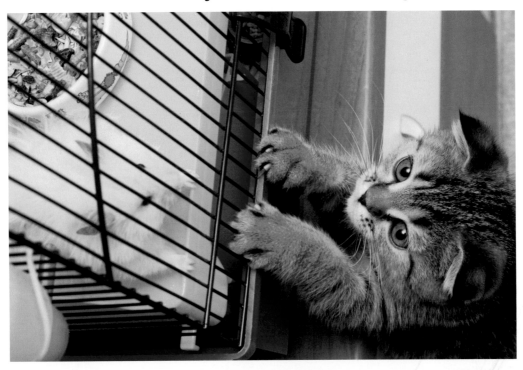

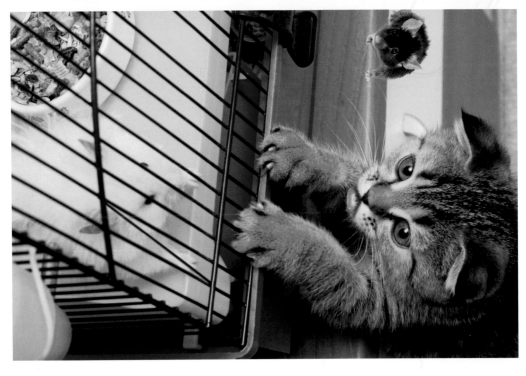

8 Changes ♡♡♡♡♡♡♡♡

It's a Butte!

**One of Utah's famous rock formations has reformed.
Which landscape's been reshaped?**

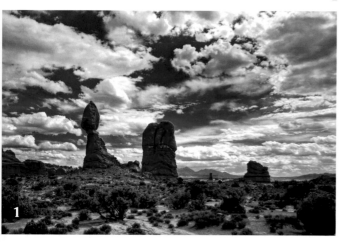

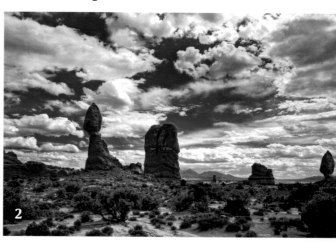

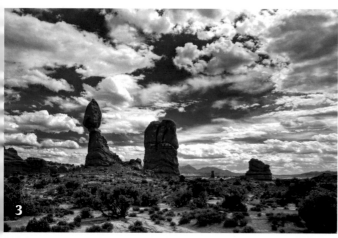

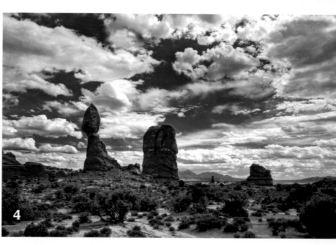

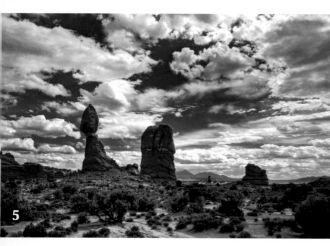

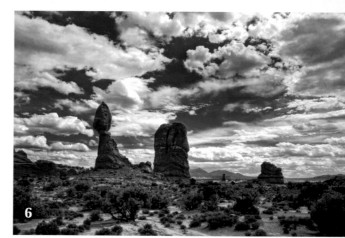

On Your Mark!

Get set! Go! A bunch of things are off-course on this track.
The race to find them starts now.

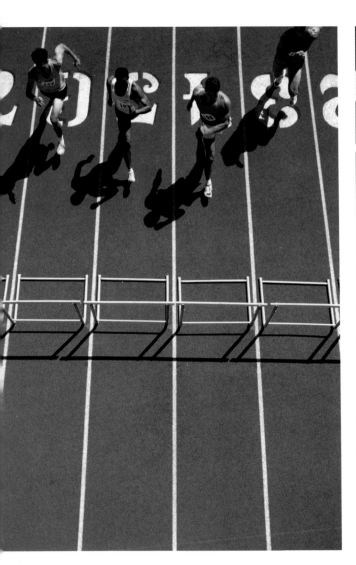
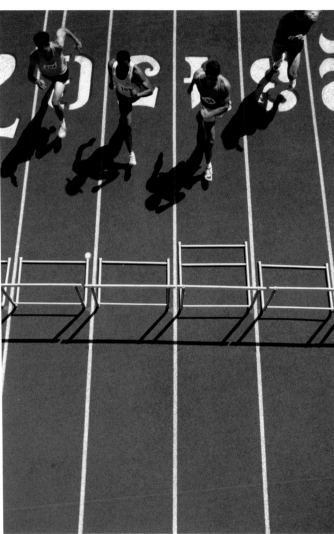

All-American Girl

Can you make heads or tails of this patriotic puzzle?

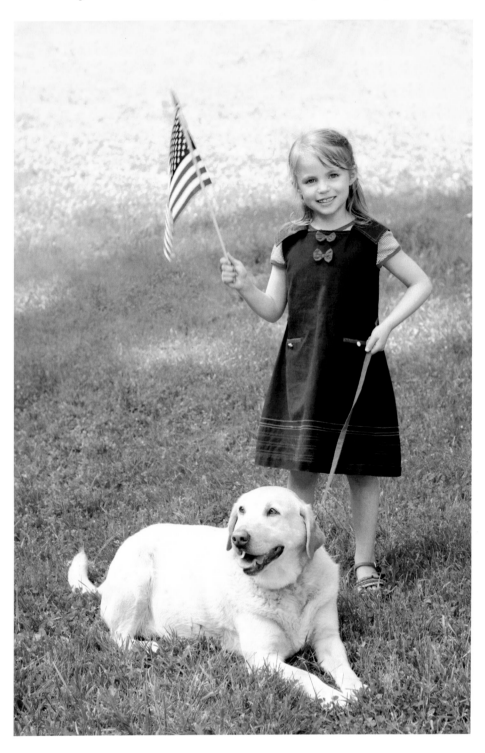

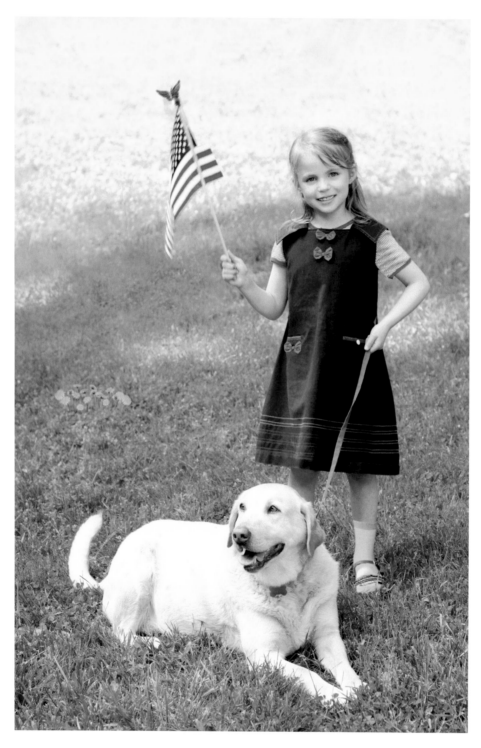

Congratulations . . .

. . . are in order! Celebrate by solving this puzzle!

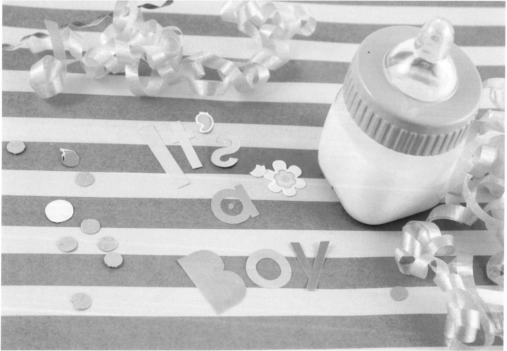

9 Change

It's Cool to Stay in School

Sometimes, the wheels on the bus do more than just go round and round.

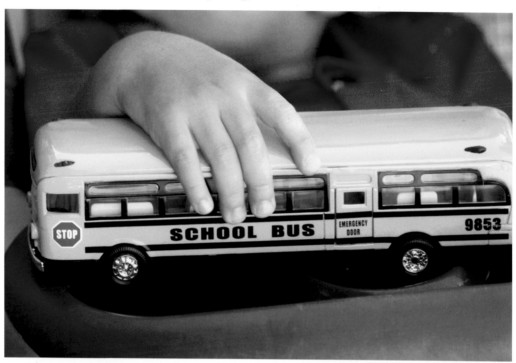

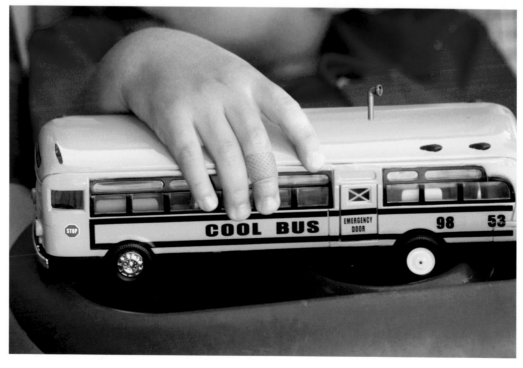

Make a Clean Sweep . . .

. . . and rake in all the changes in this puzzle.

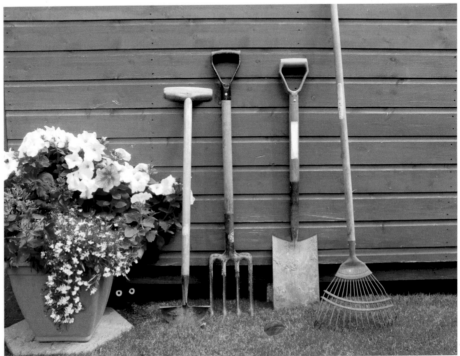

8 Change

Breakfast Bonanza

These blueberry waffles are all mixed up.
See if you can reset the table.

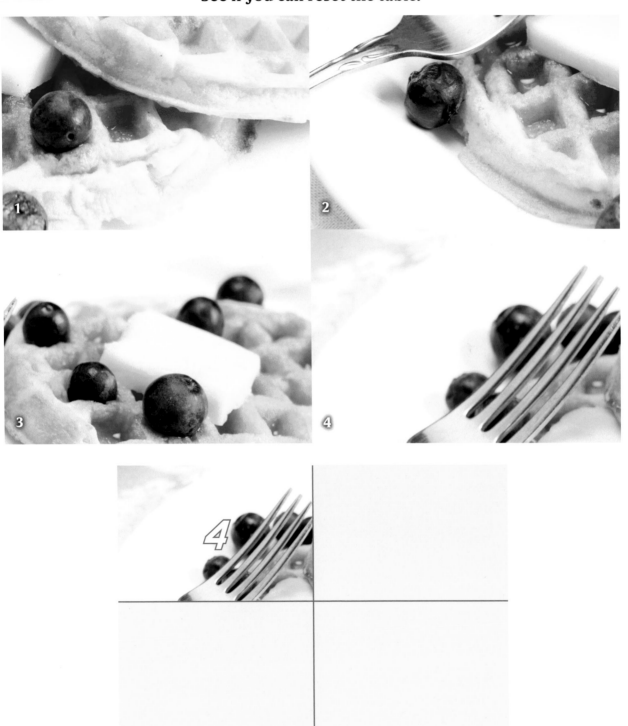

Slip-Sliding Away!

Uh–oh. Looks like we've got company.

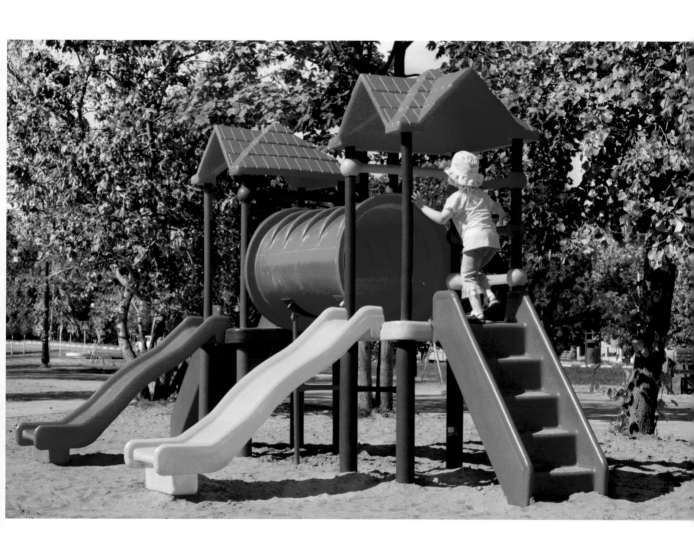

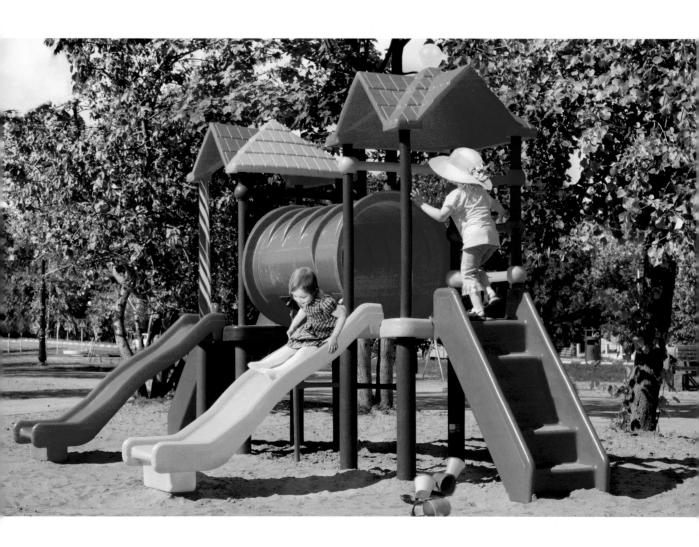

Hop Right In . . .

. . . and skip around to find the one that's different.

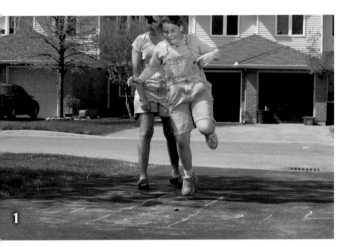

1

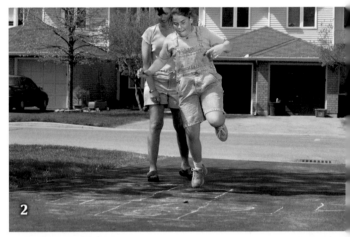

2

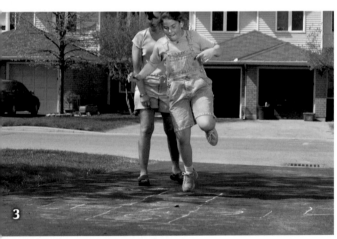

3

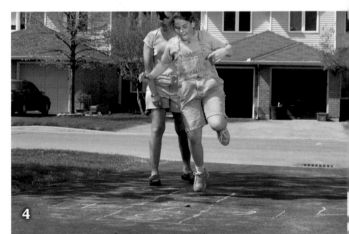

4

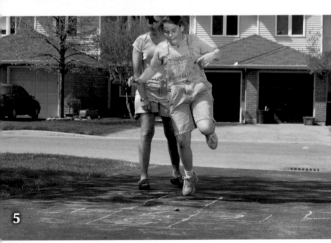

5

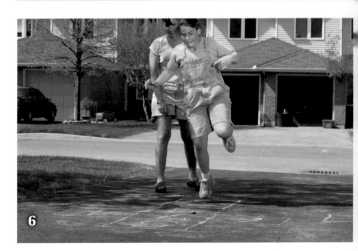

6

Bugle Boys

Tap your puzzling capabilities and blow away the competition.

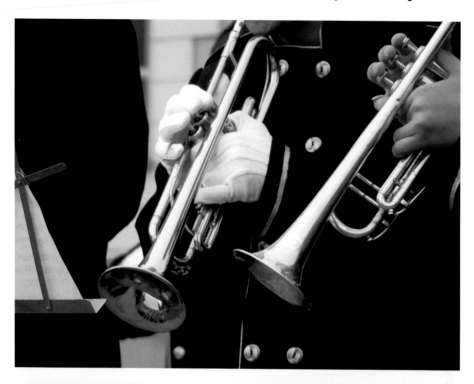

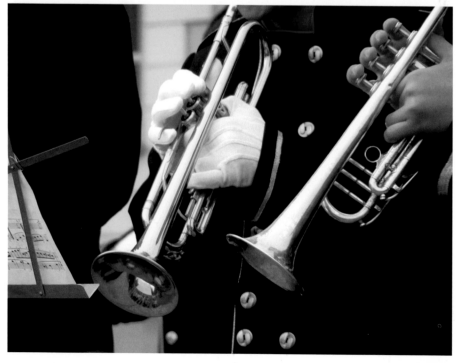

8 Changes

Practice Makes Perfect

This scene may give you a run for your money.

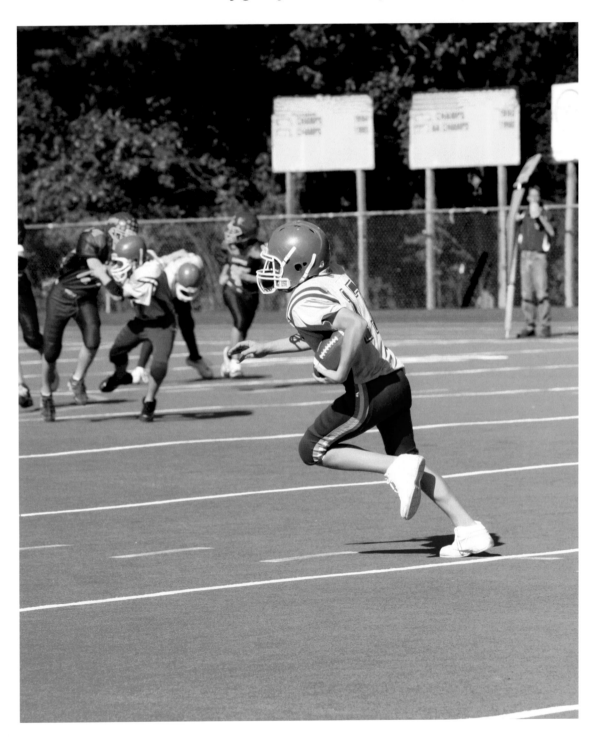

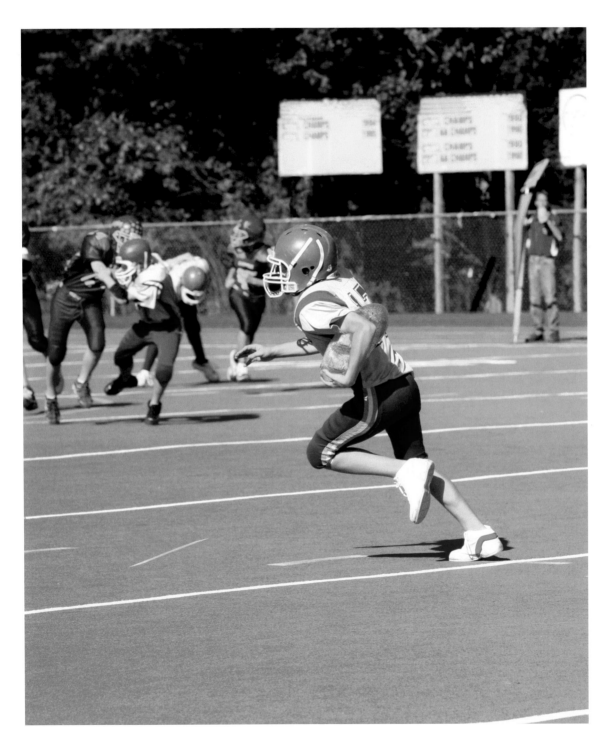

Southwestern Switch Up

One of these cacti is not like the others.
Don't get prickly—just find it!

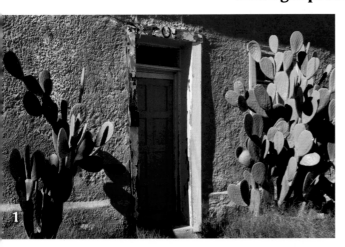

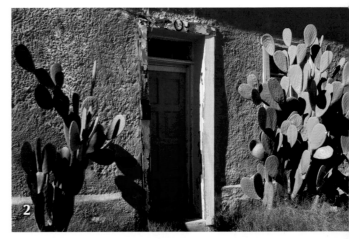

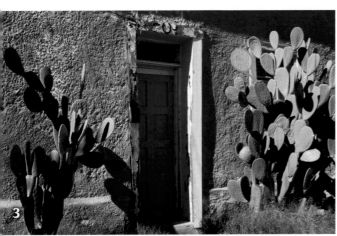

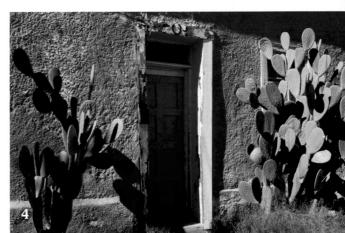

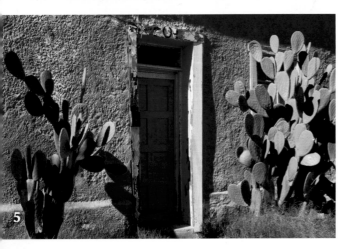

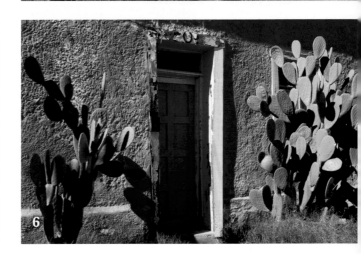

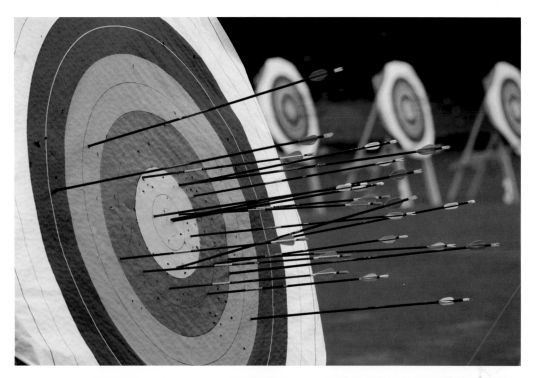

Bull's-Eye!

Go ahead, take your best shot.

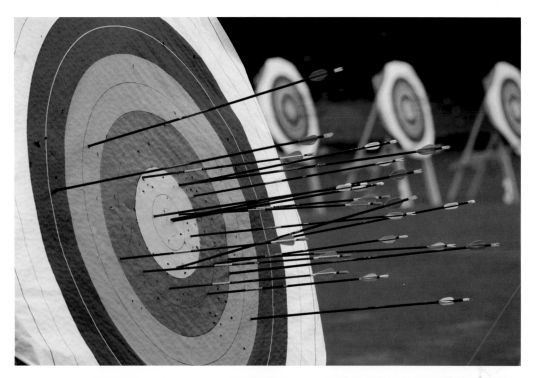

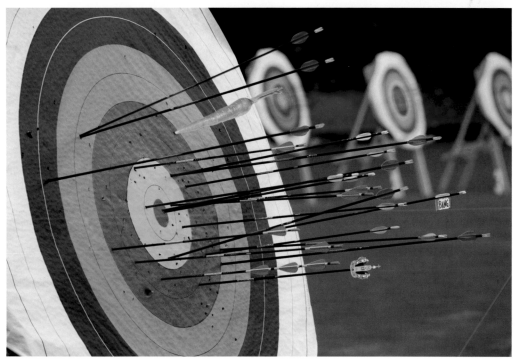

USA TODAY.

Bead-Decked at Mardi Gras

Can your bead-y eyes spot the Big Easy lamppost that's different?

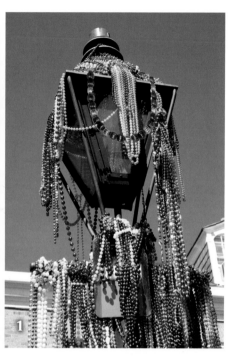

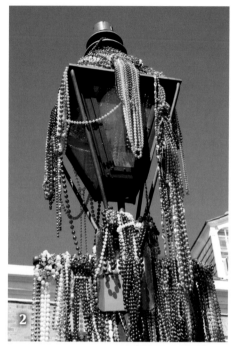

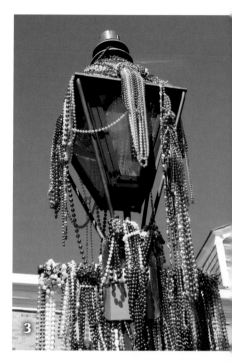

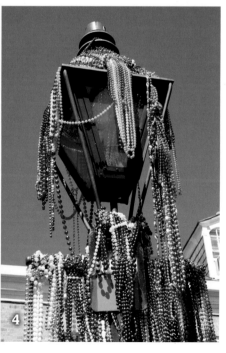

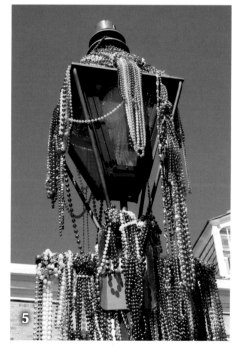

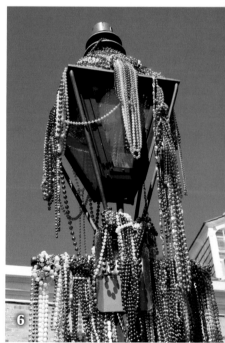

Painting Prodigy

Quick! Find all the changes before she paints over them!

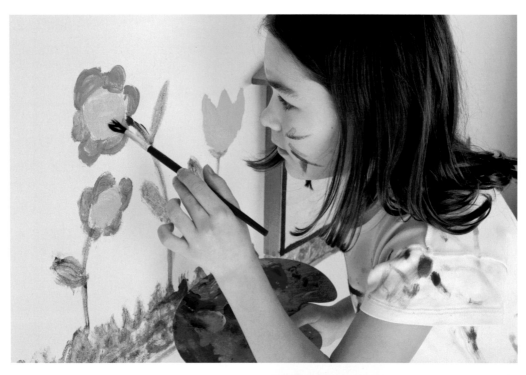

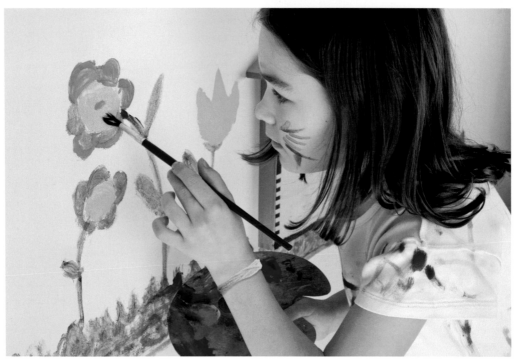

8 Changes

Take Your Best Shot

Pool your talents and you'll rack up some serious points!

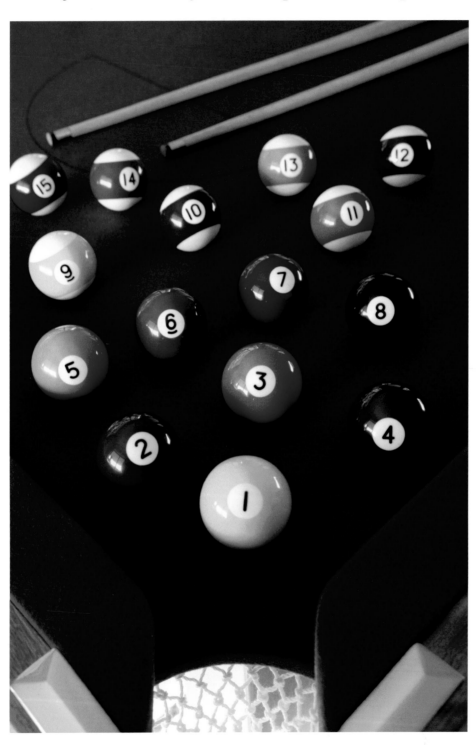

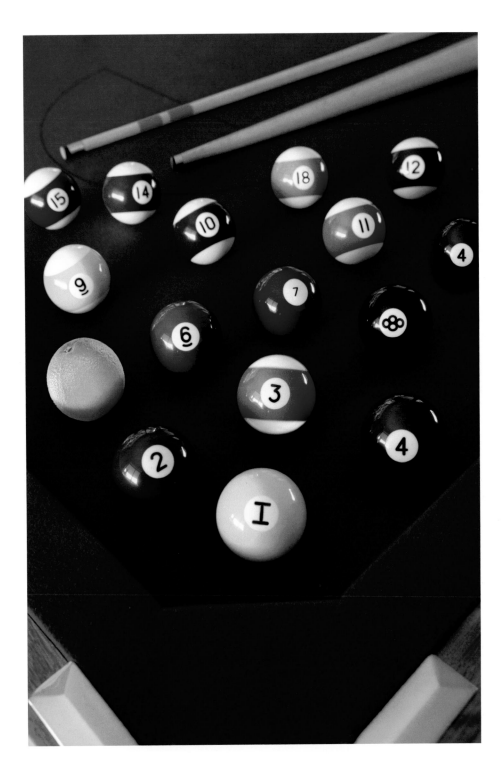

Beautiful Bunch

One of these bouquets is not like the others.
Can you sniff out the floral impostor?

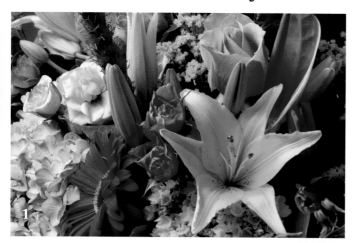

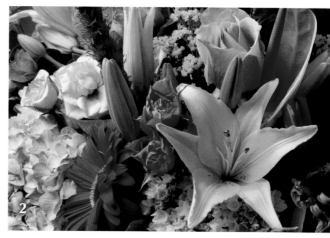

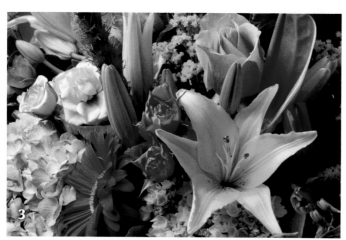

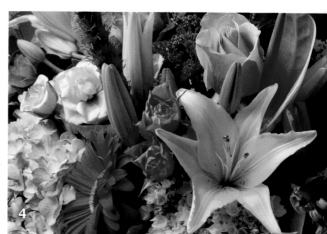

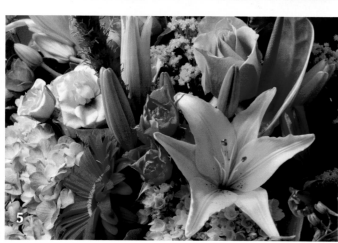

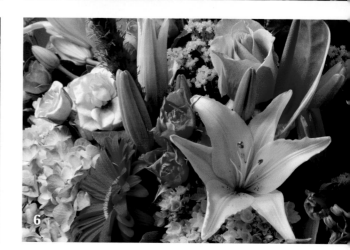

Jukebox Jive

**Feast your peepers on the juke joint below.
Are you hep to the changes?**

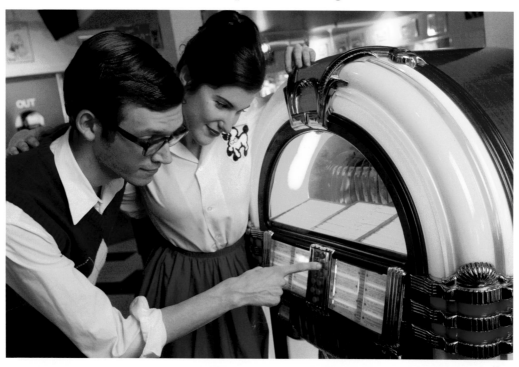

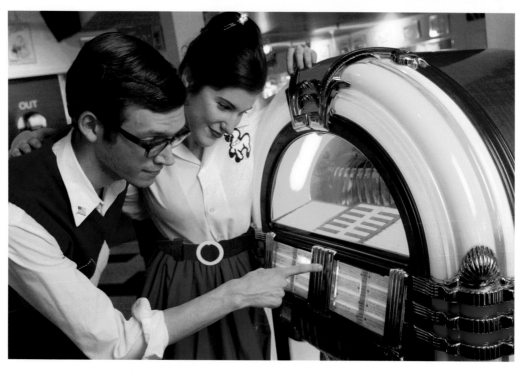

Changes ♡♡♡♡♡♡♡♡♡

Keep Your Eyes Peeled

**A chef never shares her secrets.
You'll have to find them on your own.**

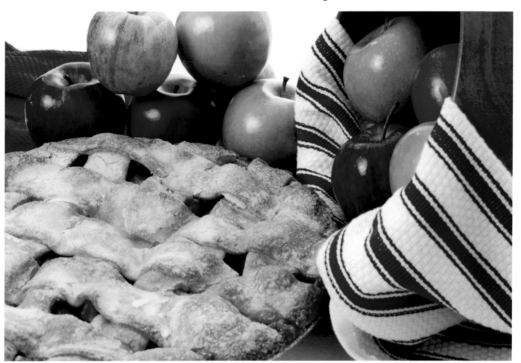

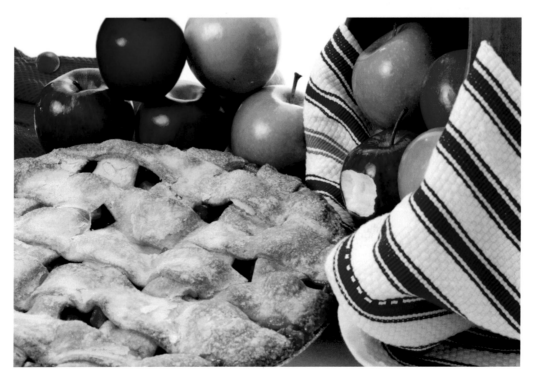

10 Change

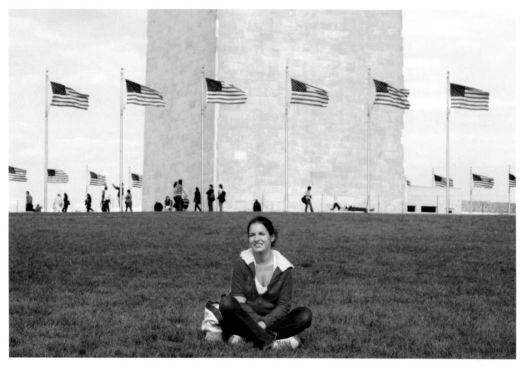

Welcome to Washington

**The differences aren't monumental,
but you should be able to pick them out of the crowd.**

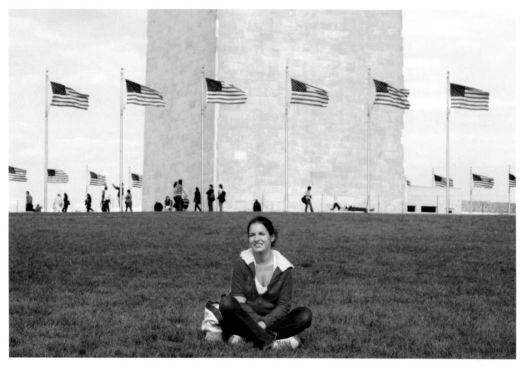

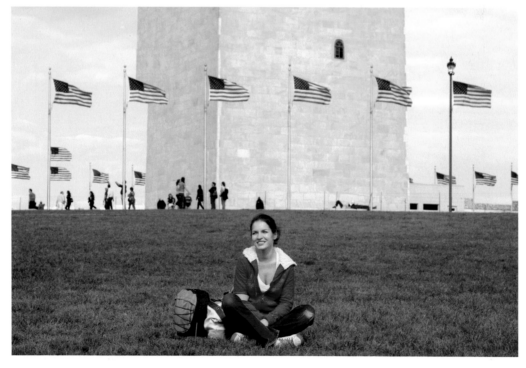

Who Do You Love?

Maybe a magnetic field will direct you to the changes you seek.

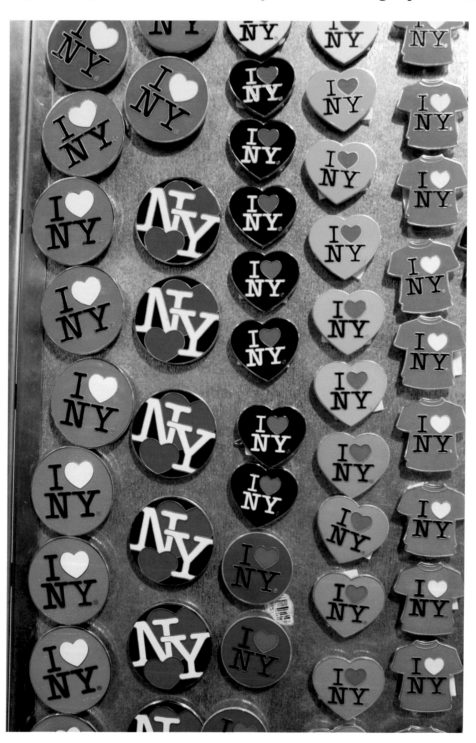

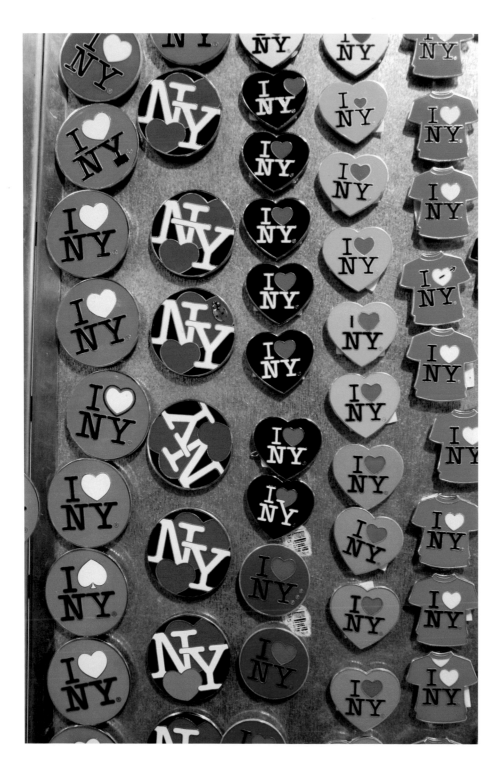

Pug-get about It!

Some pups march to the beat of a different drummer.

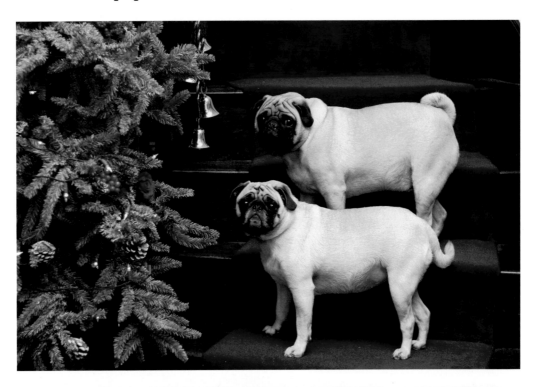

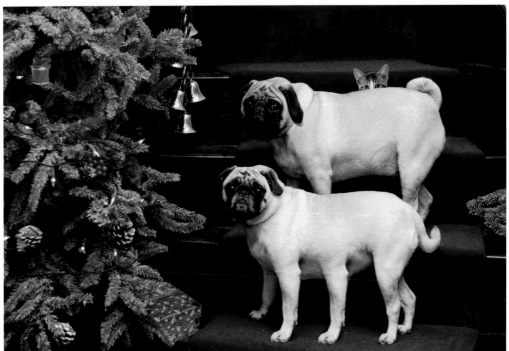

 8 Change

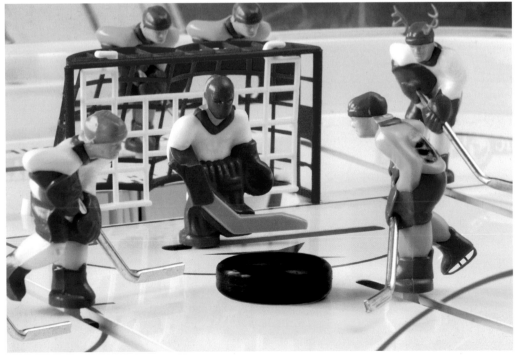
Pucker Up!

Unmask all the changes, and score big.

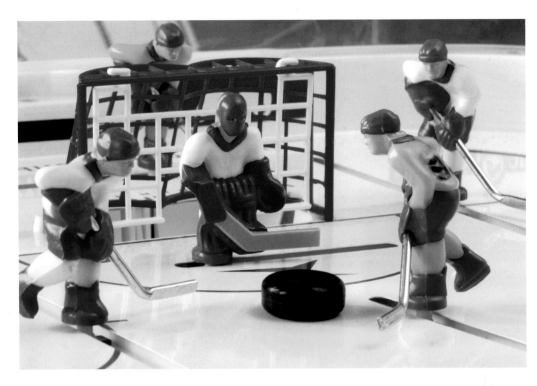

Middle of the Road

First Set of Wheels

**Put the pedal to the metal to find the modifications
made to this mod mode of transportation.**

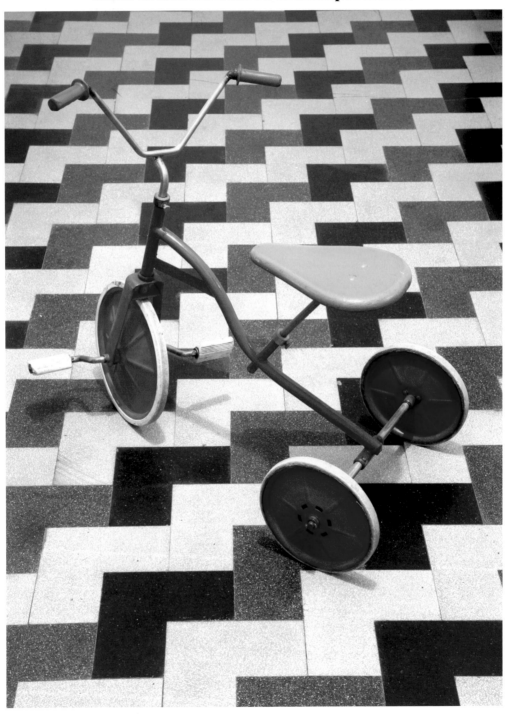

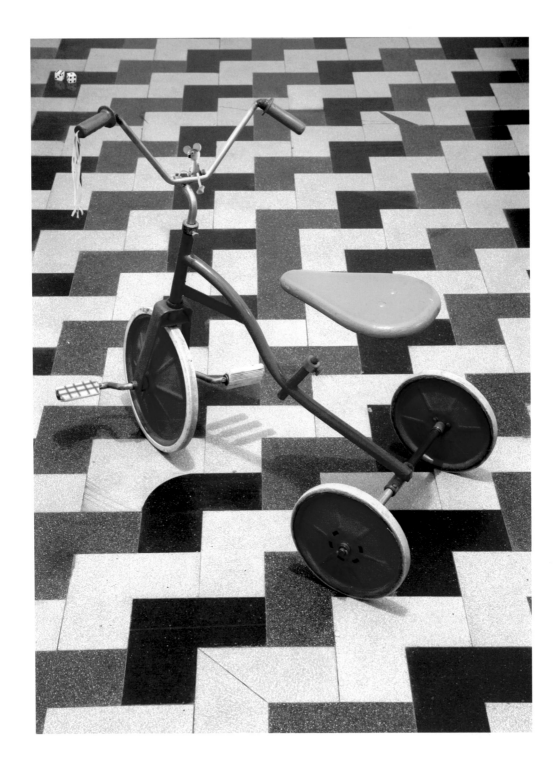

Sock It to Me!

You'll definitely earn your stripes when you fix up the fall scene below.

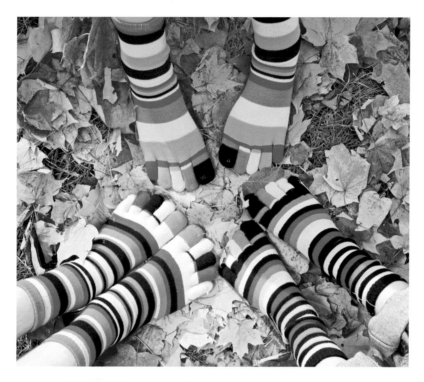

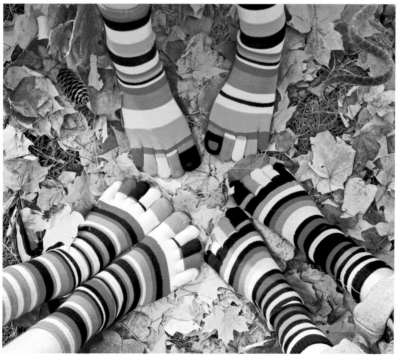

7 Changes

Fresh from the Farm

Hope you've been eating your carrots.
You'll need 20/20 vision to discern the differences below.

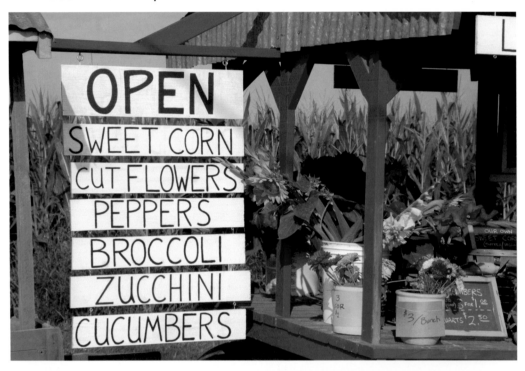

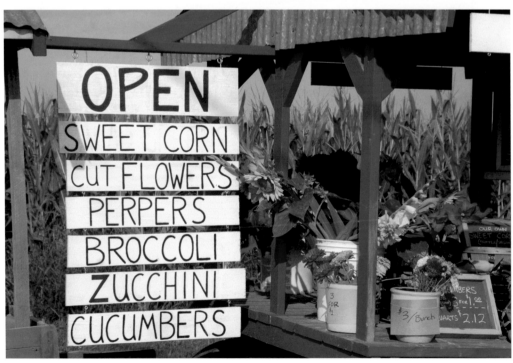

Rocky Mountain Mix Up

**Stumbling across one bear is scary. Stumbling across six is TERRIFYING.
Find the one that doesn't belong.**

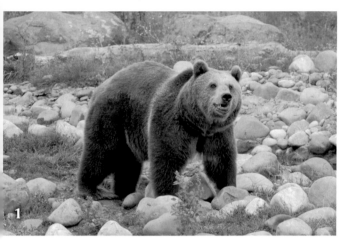

1

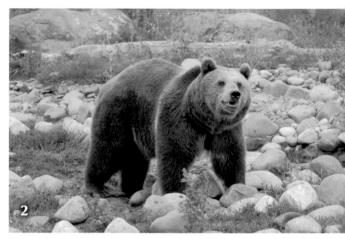

2

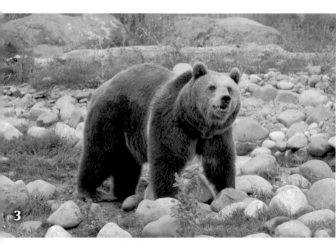

3

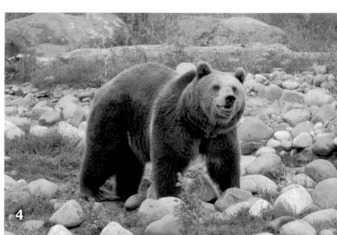

4

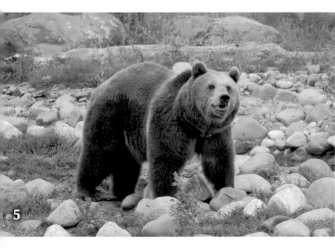

5

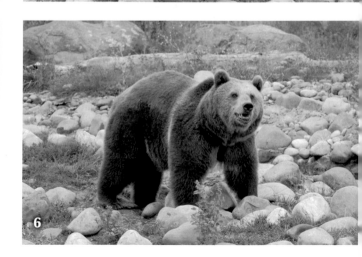

6

Meet Me at Level 14!

Take a gander at the game room and see how we've redecorated.

Come and Get It!

Patio Daddy-o is serving up burgers that are out of this world.

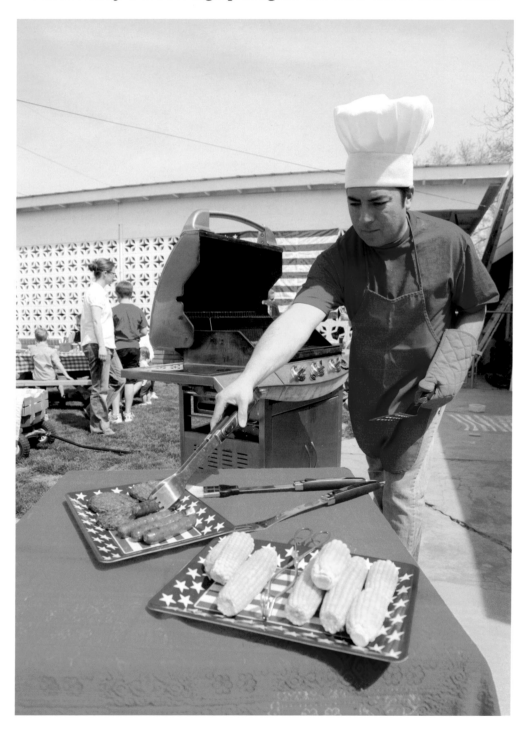

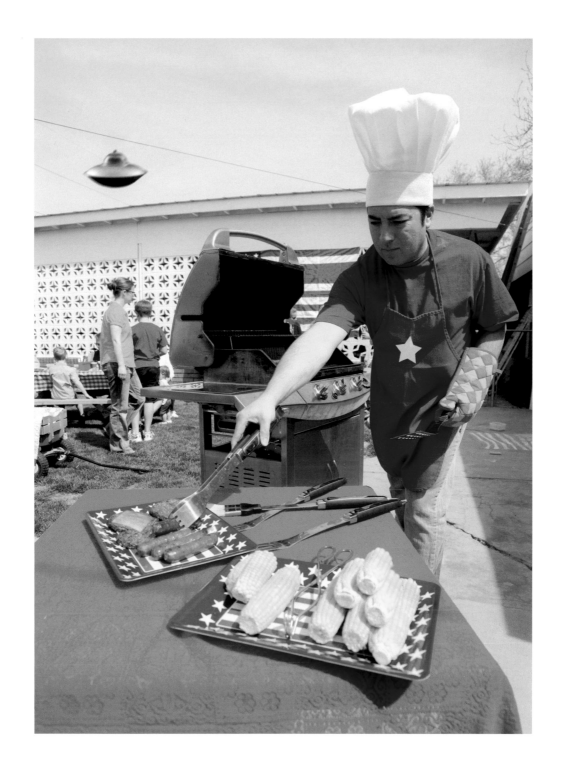

Start Your Engine

**This classic car has been more than just restored.
Earn your racing stripes by spotting the newest parts.**

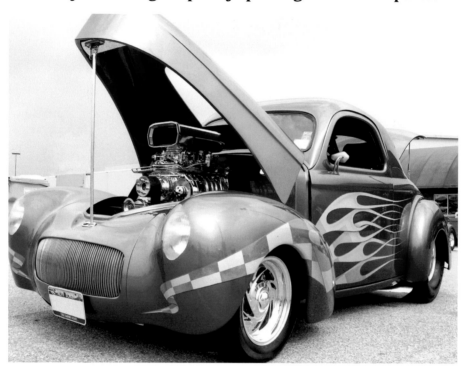

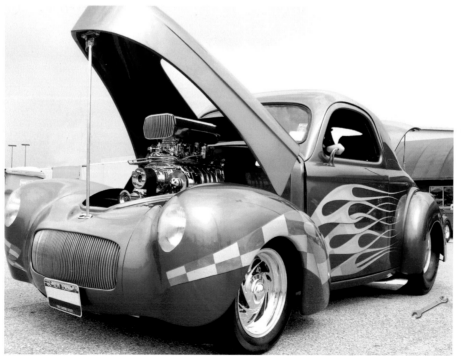

◯◯◯◯◯◯◯◯ *8 Changes*

Good Cheer

Let's go, puzzler, let's go!

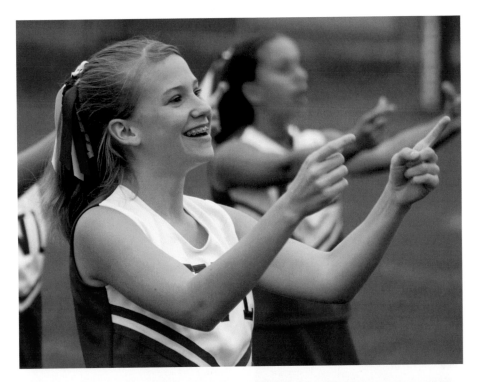

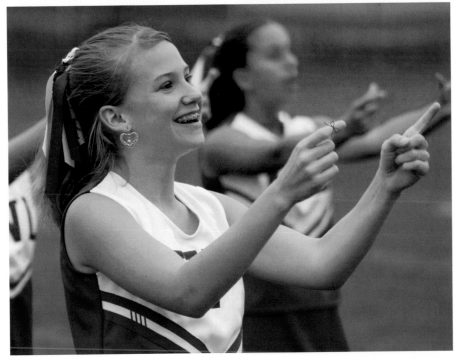

The Honeymoon Phase

**This happy couple will look at their photos for years to come.
You might, too, unless you can locate the standout.**

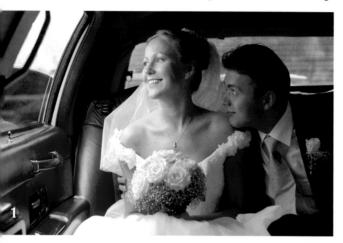

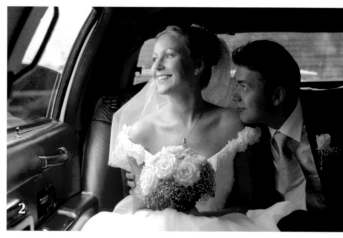

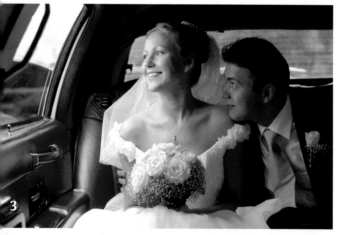

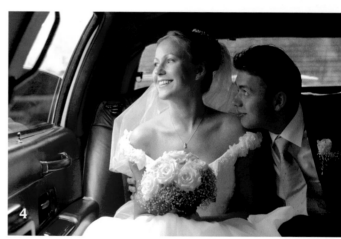

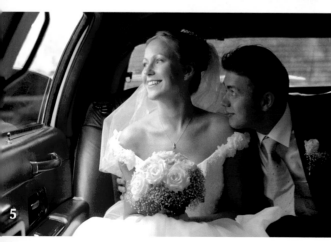

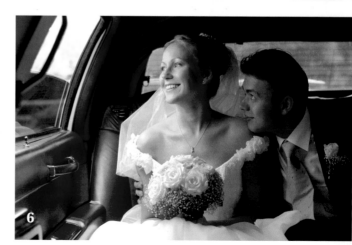

Gobble Gobble!

Give thanks once you've found every last change on the table.

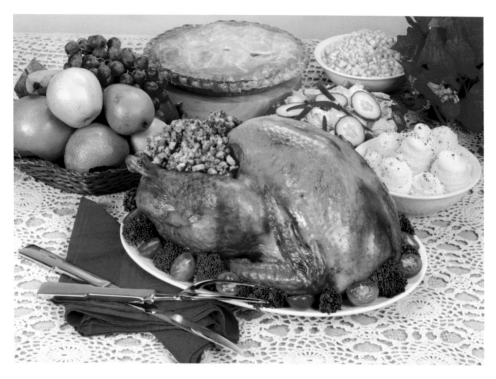

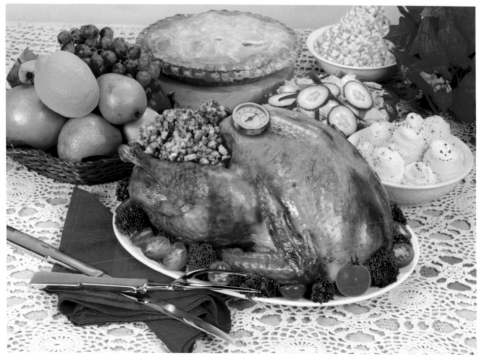

10 Changes ♡♡♡♡♡♡♡♡♡♡

Seattle Streetcar

**Here's a city that's growing so fast
you'll barely recognize it from one picture to the next.**

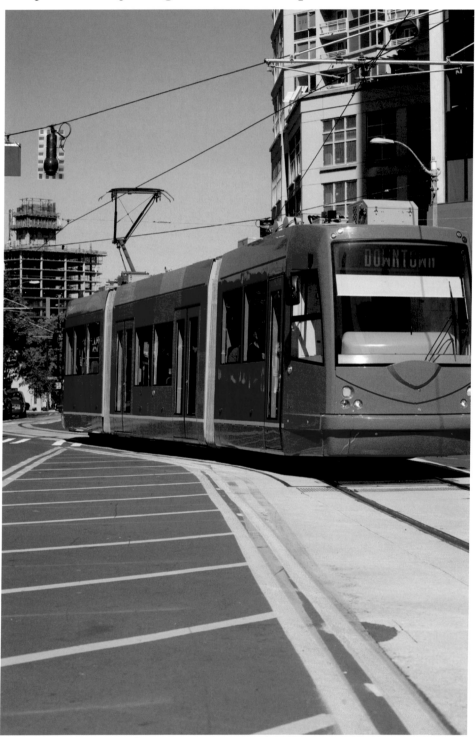

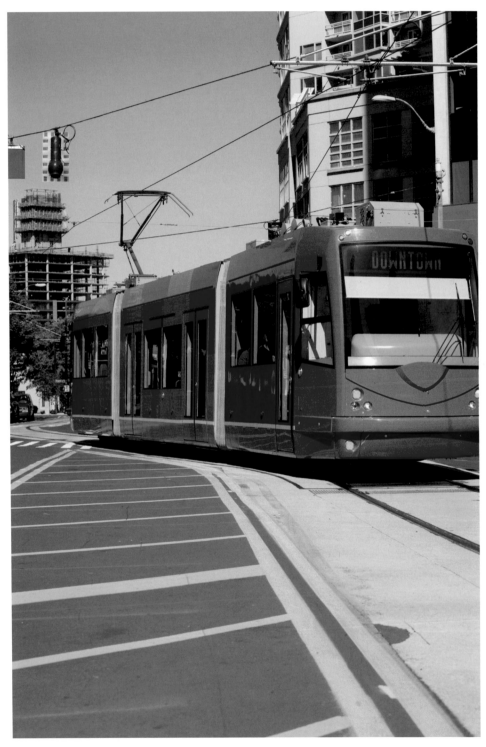

Wisconsin Dairy Farm

Got changes?

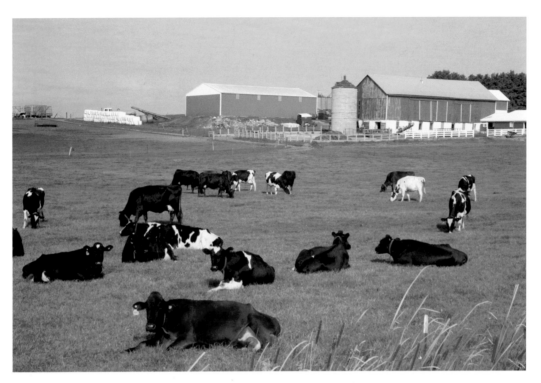

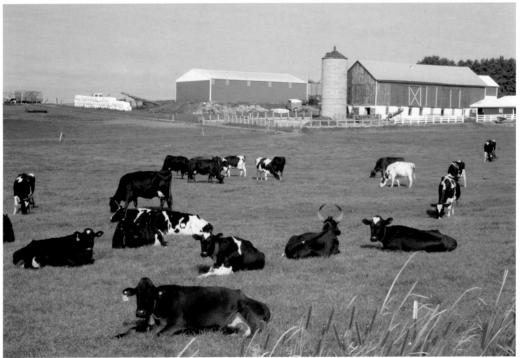

11 Changes

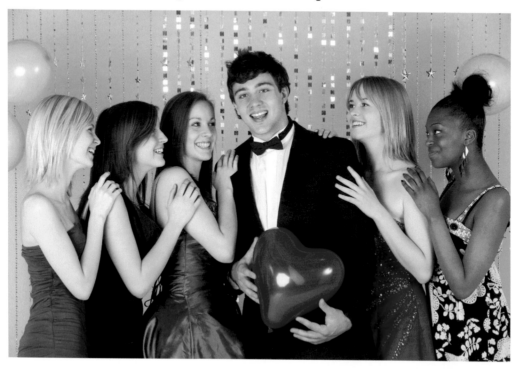
Heartbreaker!

**Who cares about his dance moves?
We're only interested in his puzzle skills.**

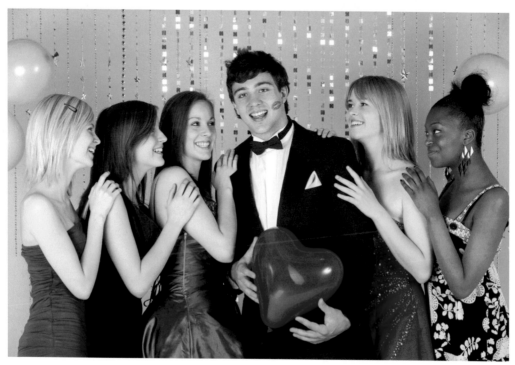

12 Changes ♡♡♡♡♡♡♡♡♡♡♡♡

Shred the Gnar!

Then put the snowboarder back together again.

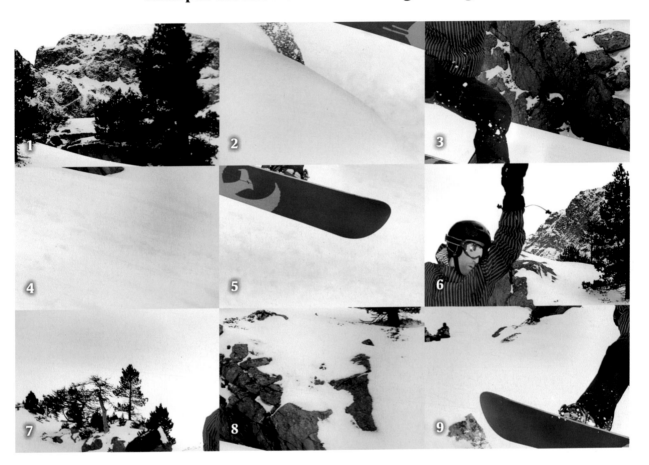

Don't Mess with Texas

There's a new sheriff in town.

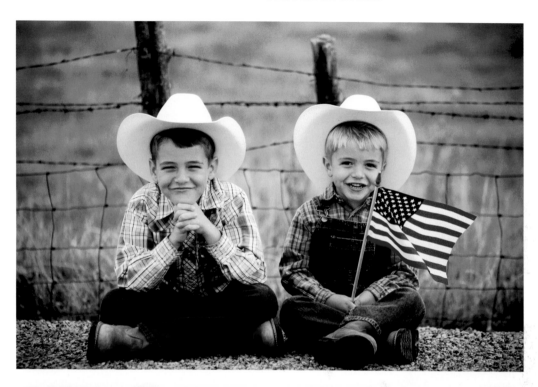

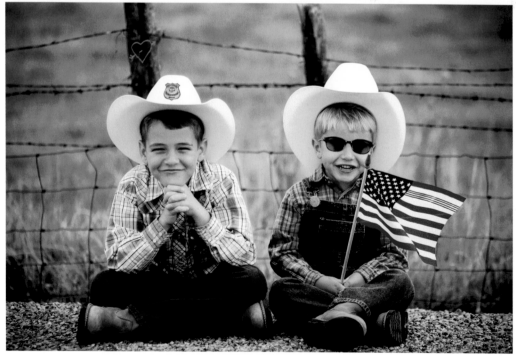

10 Changes

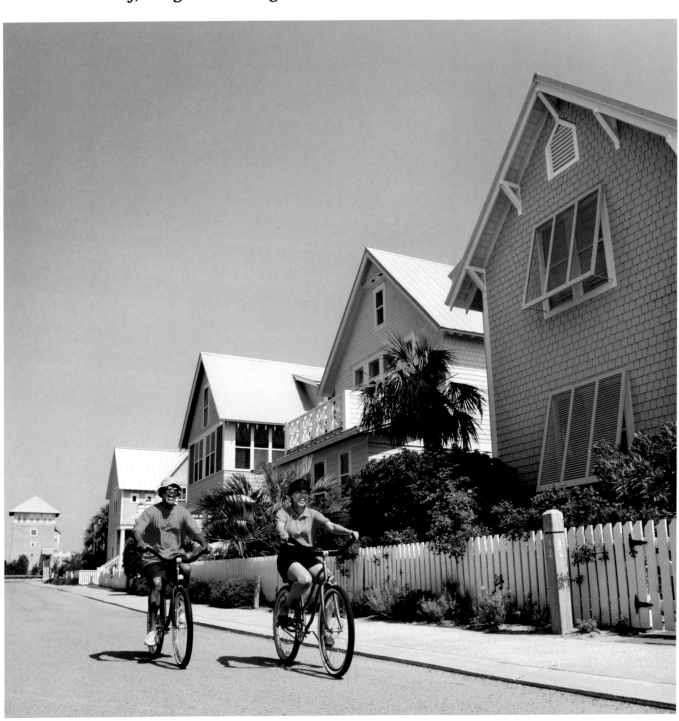

North Carolina Getaway

"My, things have changed since we last visited the time-share."

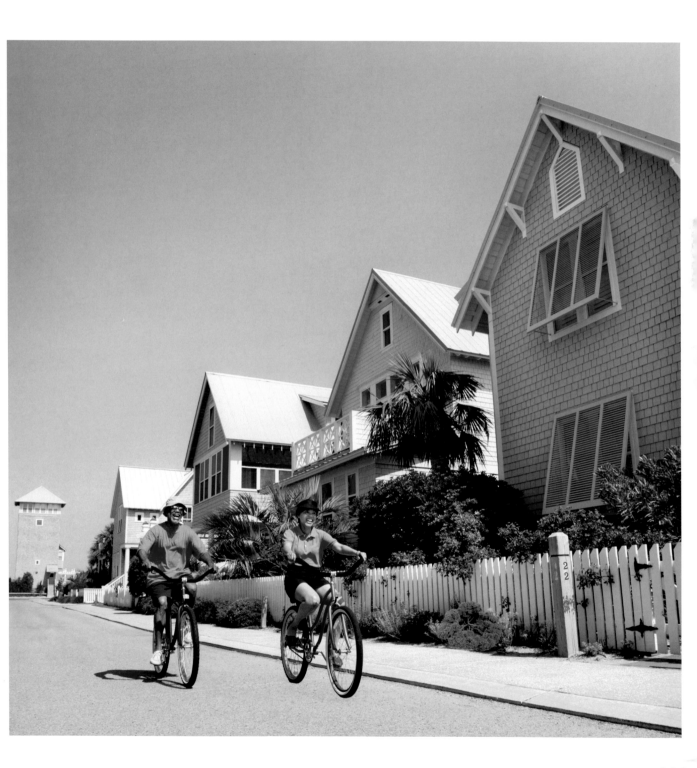

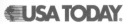

Flower Power

Chalk up any changes to this little sidewalk artist's creative license.

Rubber Ducky Makeover

What song would Ernie sing about this flotilla of shady dudes?

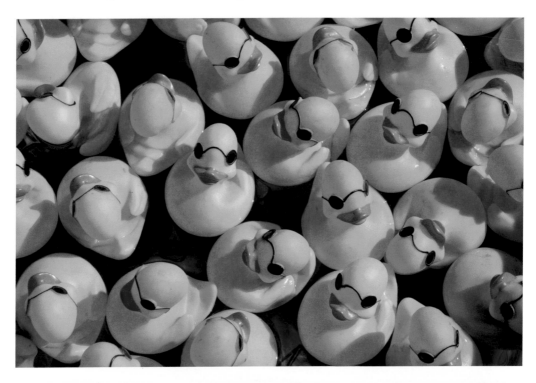

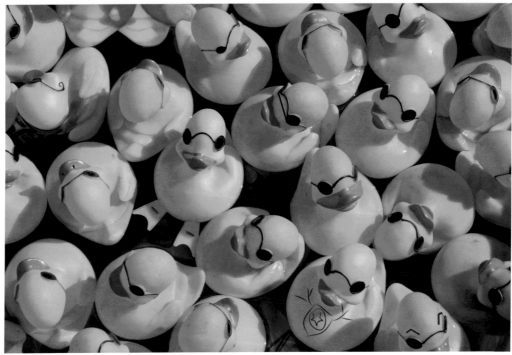

12 Change

Hand-Stitched

SEW many changes.

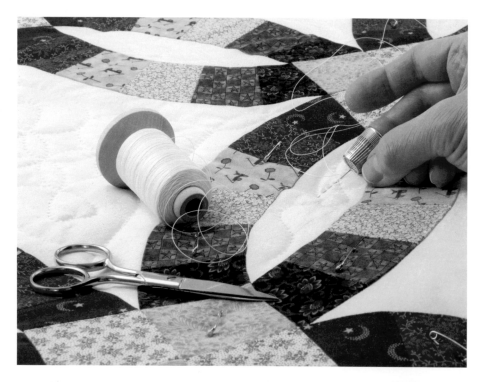

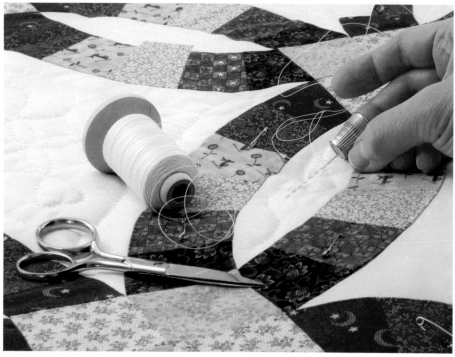

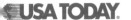

Toy Box Gridlock

Can you puzzle your way out of the congestion?

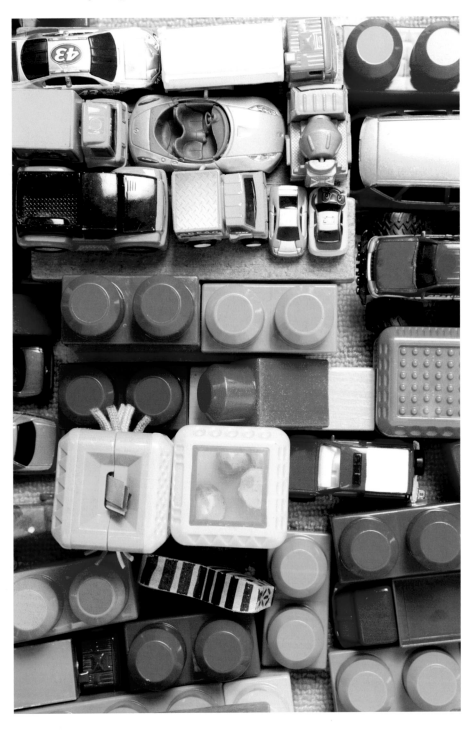

Miami Style

Put your skills on cruise control and park this "pink lady" in the solved zone.

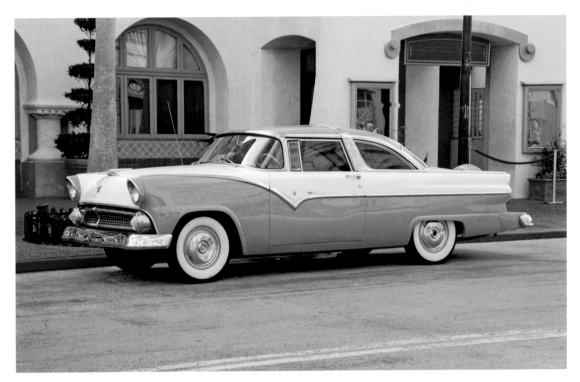

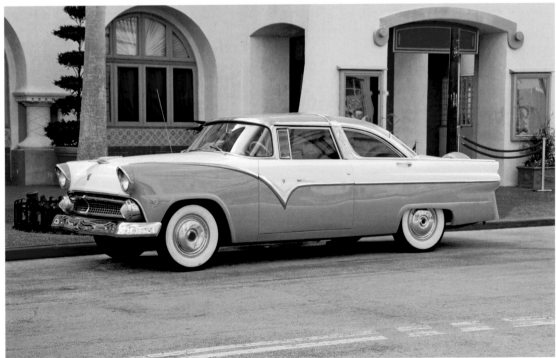

○○○○○○○○○○ *10 Changes*

Master Chef

**No alterations, recipe or otherwise,
escape the professional eye of this pint-sized chef.**

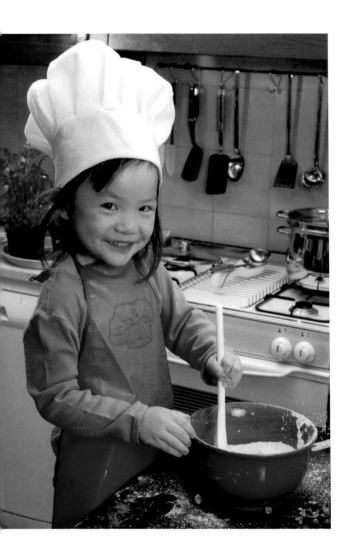
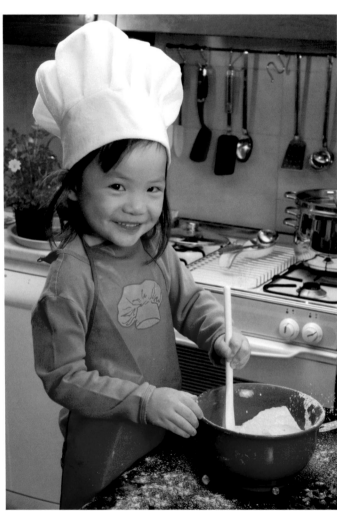

I "Vitamin C" You!

**Not a chance of scurvy for these two!
Orange you glad you found all the changes?**

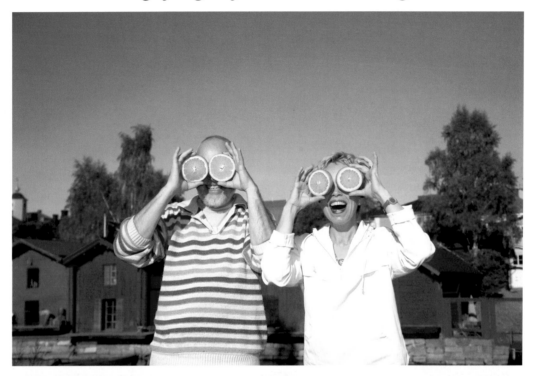

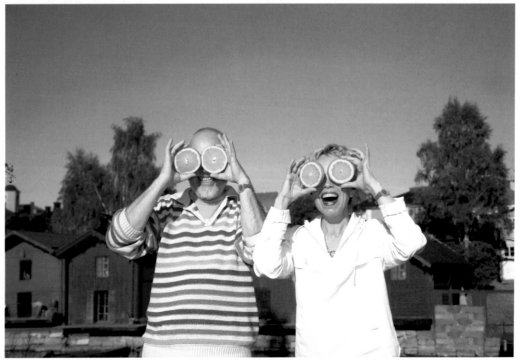

9 Change

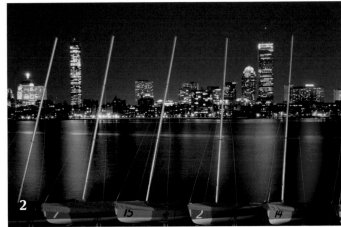

Becalmed in Boston

But you won't be, until you find which river scene has been revised.

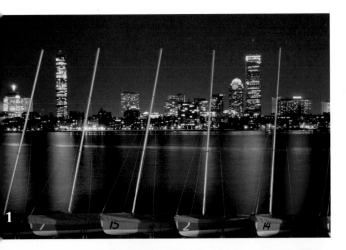

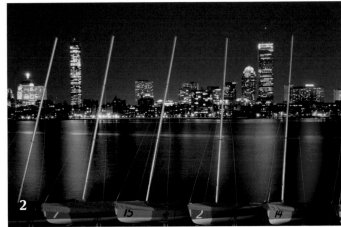

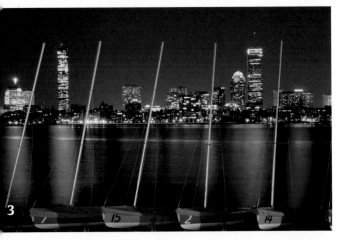

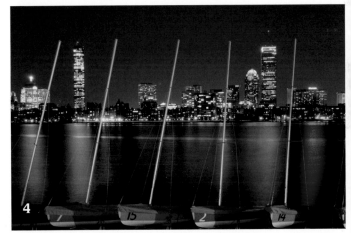

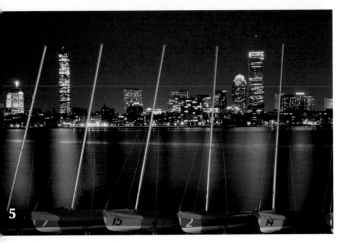

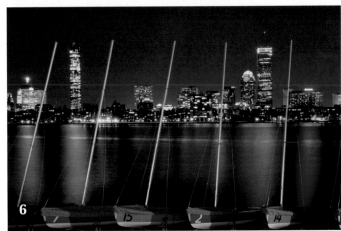

Handmade Bazaar

**You'll have to get crafty, too, if you want to unearth
the adjustments made to this pottery stand.**

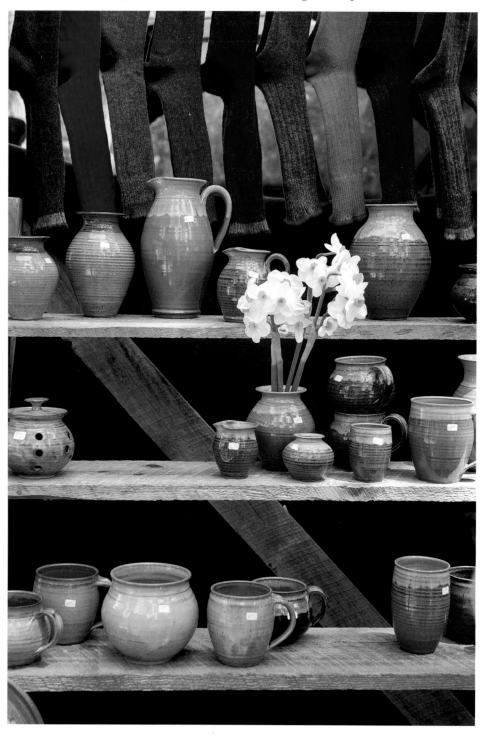

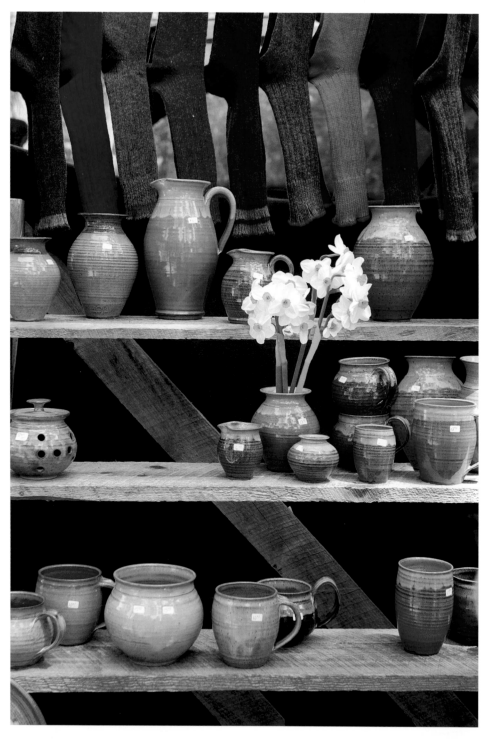

Oh, Say Can You See . . .

. . . the differences between these two parade pics?

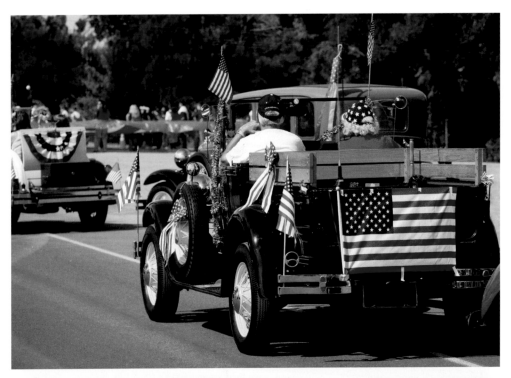

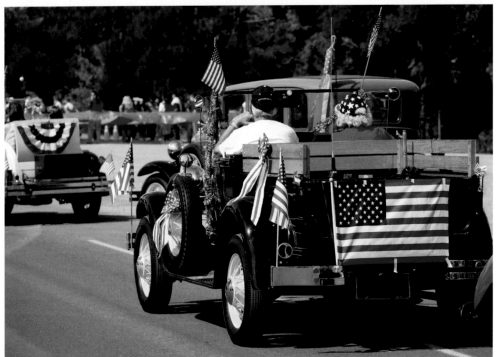

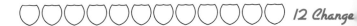 *12 Change*

Do You Hoola?

It's harder than it looks to find the one and only change.

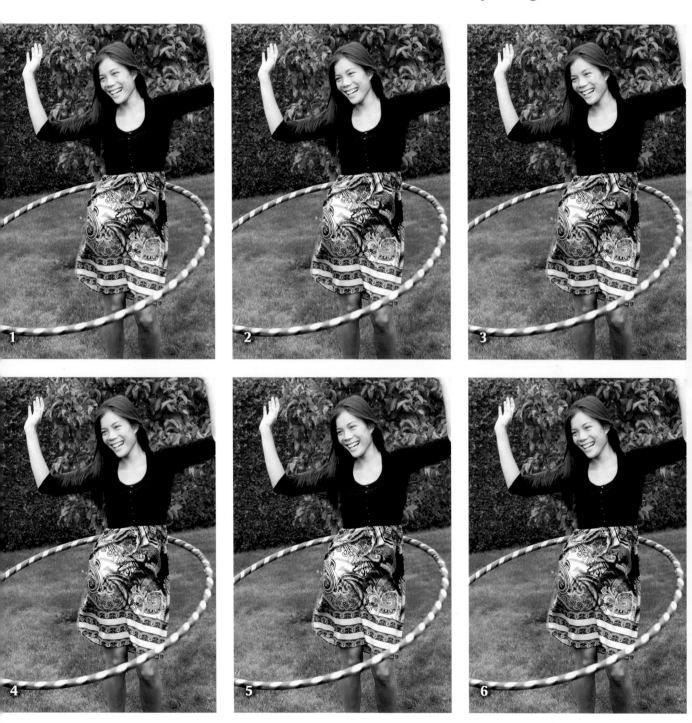

Sibling Rivalry

**Something's fishy with this photo.
Keep looking and you're sure to get hooked.**

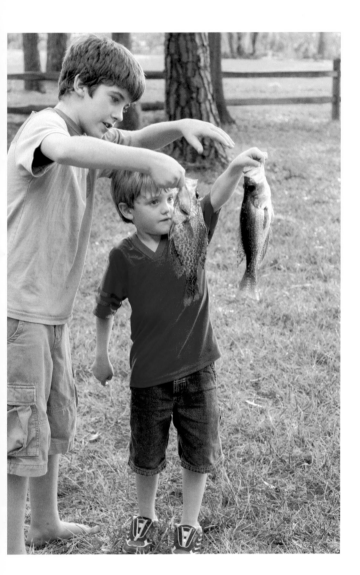 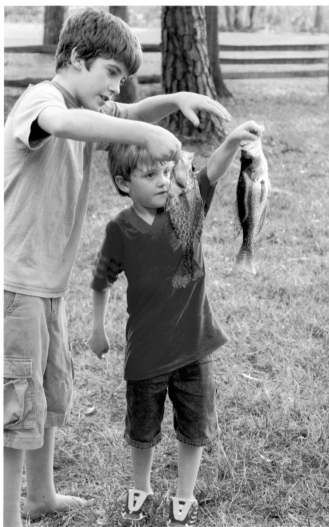

$\bigcirc\bigcirc\bigcirc\bigcirc\bigcirc\bigcirc\bigcirc\bigcirc\bigcirc$ *9 Changes*

Outstanding in Her Field

The hills are alive . . .
Well, they sure are moving.

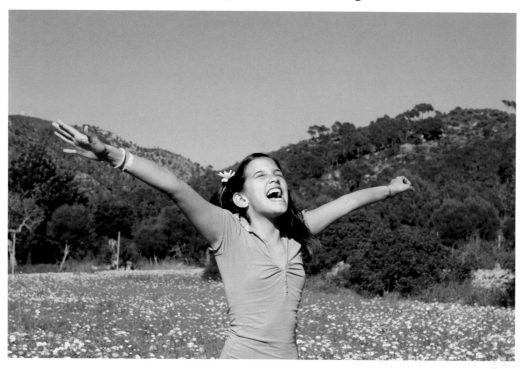

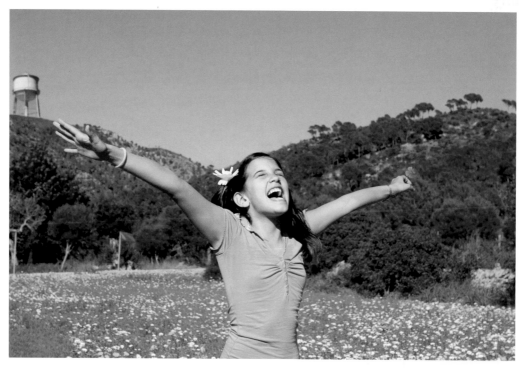

3 Changes

Viva Las Vegas!

The King's all shook up. A little less conversation, please, and a little more puzzle action.

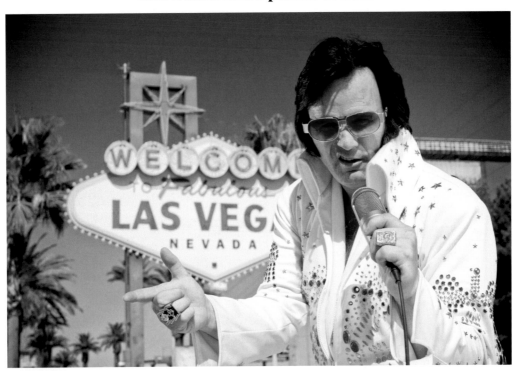

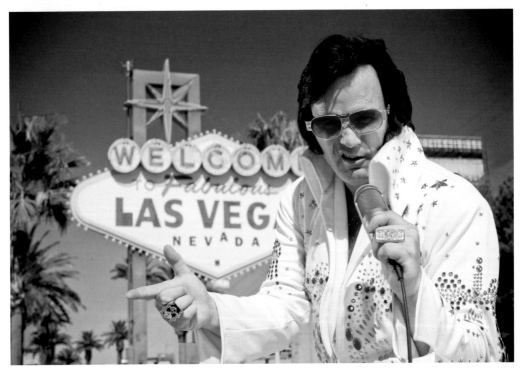

 11 Change

You Light 'Em, They Fight 'Em!

No cause for alarm, but something doesn't look right.

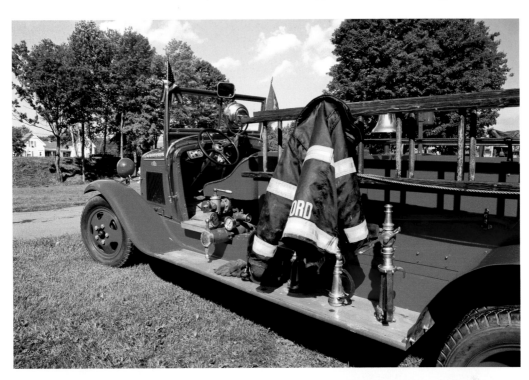

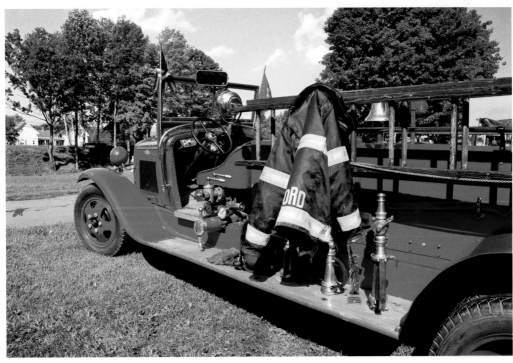

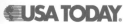

Hold On Tight!

Buck and spin your way around the photo and lasso anything that moves.

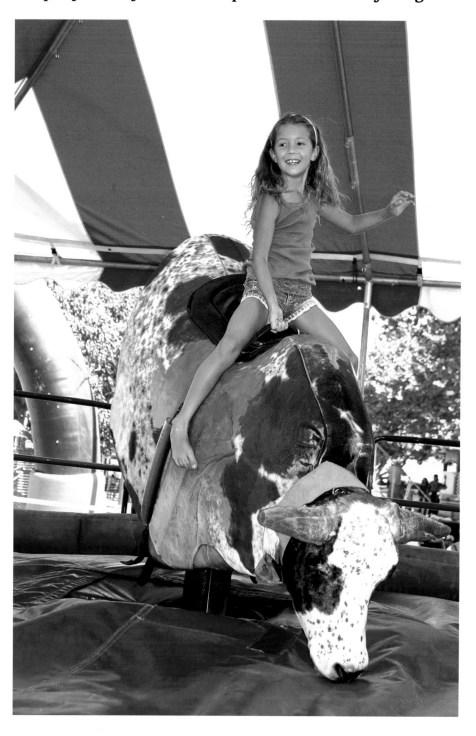

Stand Tall

Good luck tracking down the alterations to this totem.

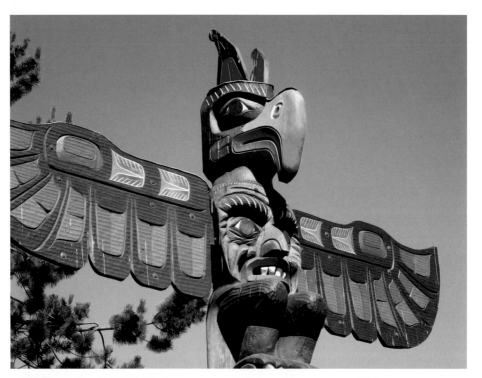

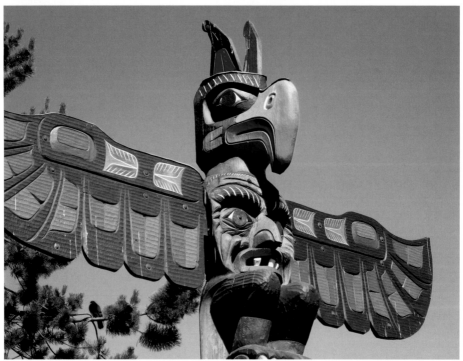

11 Changes

Let Them Eat Cake!

Look for unexpected surprises at this party.

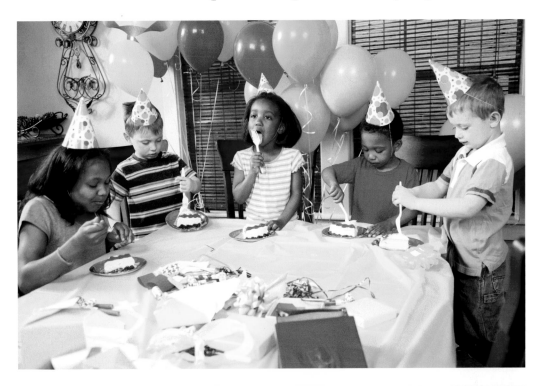

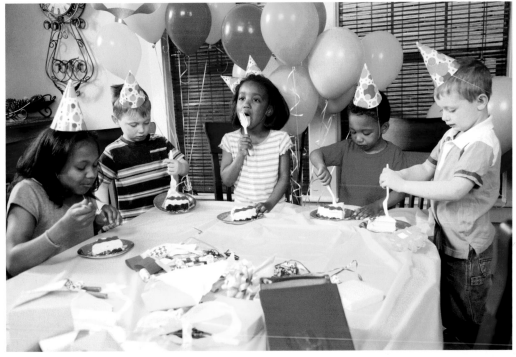

9 Changes

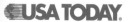

Dancing Dragon

What will YOU change in the new year?

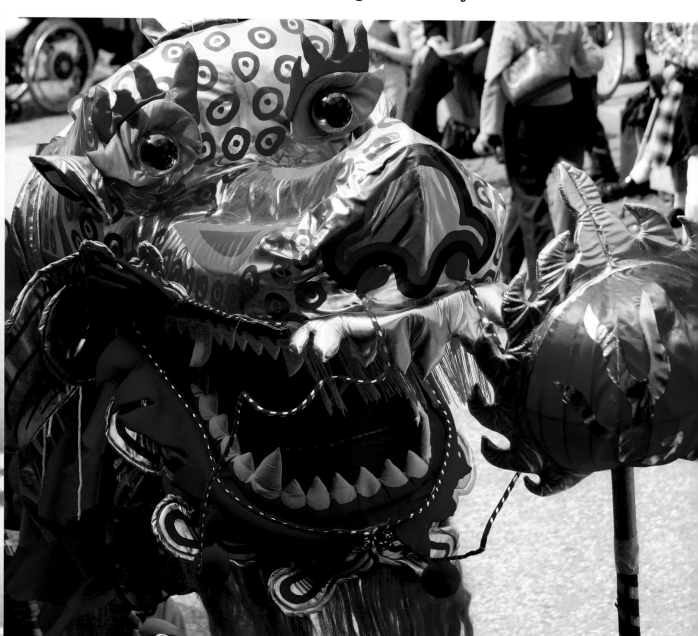

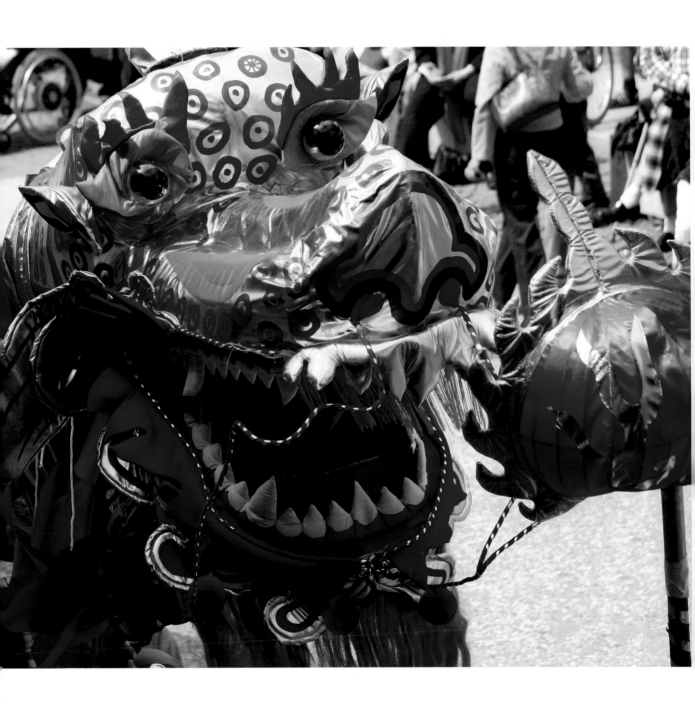

Not So Cookie-Cutter Treats

Put down the icing and step away from the bunnies.

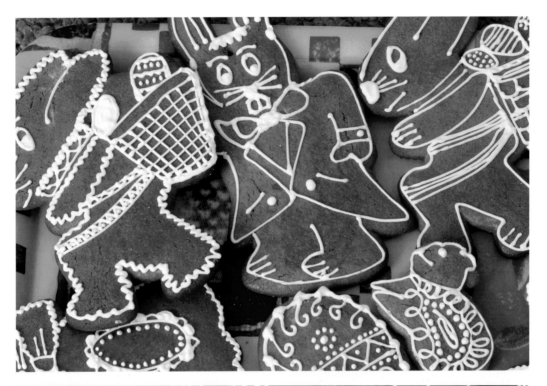

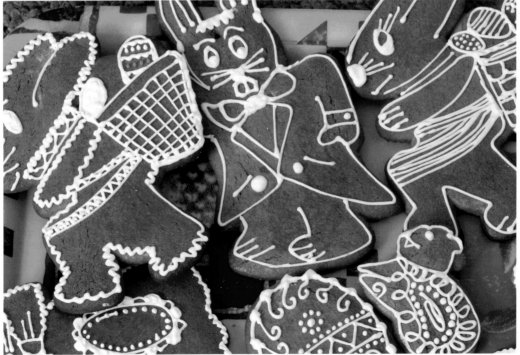

15 Changes

Hot Dog!

The mobile home isn't the only thing moving around here.

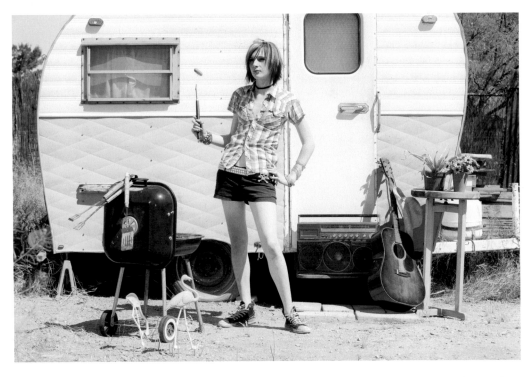

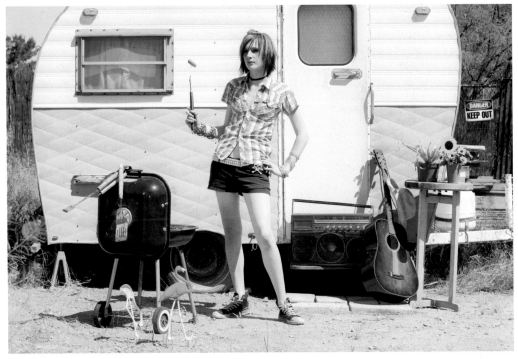

1 Changes ⬭⬭⬭⬭⬭⬭⬭⬭⬭⬭

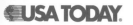

Tough Call

Rearrange the pieces and make a play!

EGGstraordinary EGGstravaganza

This puzzle gives a whole new meaning to Easter egg hunt.

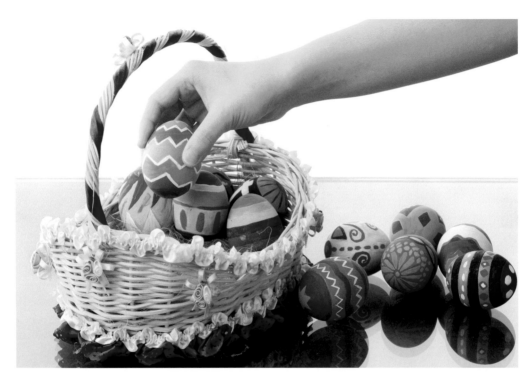

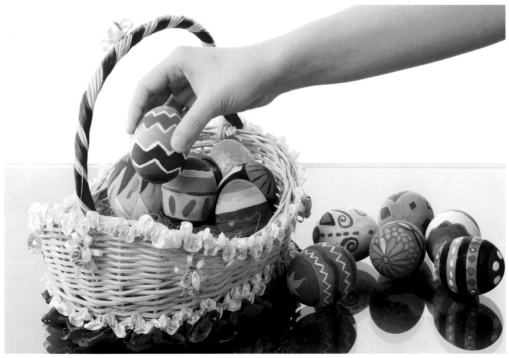

Are You Ready to Rock?

**We gave this boy band a makeover.
How do they look?**

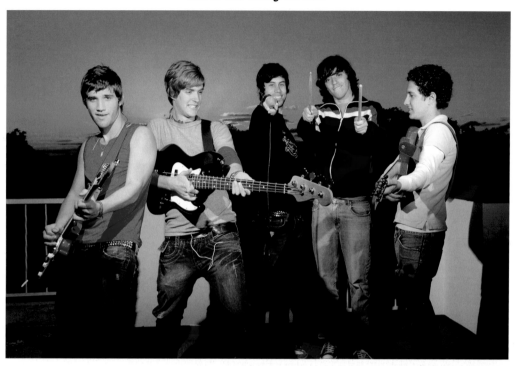

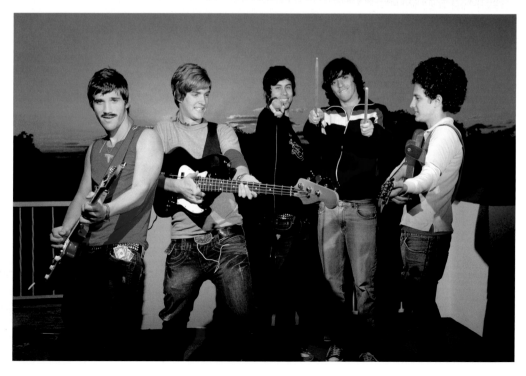

13 Changes

The Great Veggie Caper of 2010

Help! Someone tampered with my tomatoes!

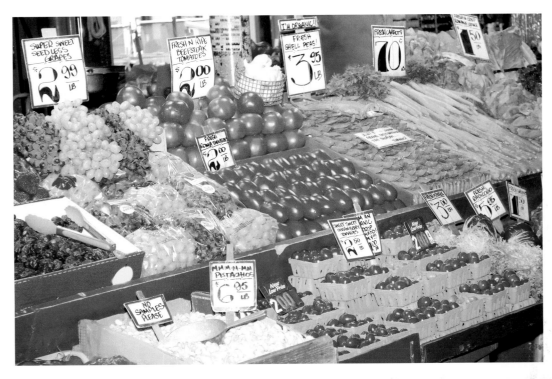

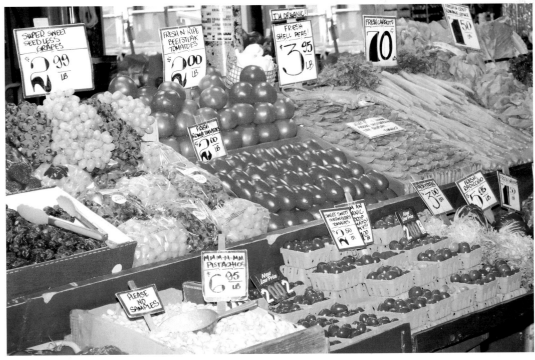

0 Changes

"Timmy, I KNOW YOU'RE UP THERE!"

"Come down here and tell me what you did to this picture!"

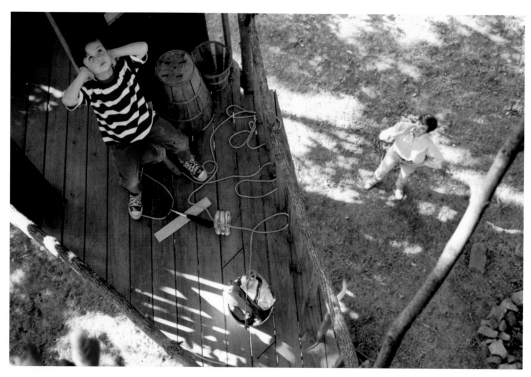

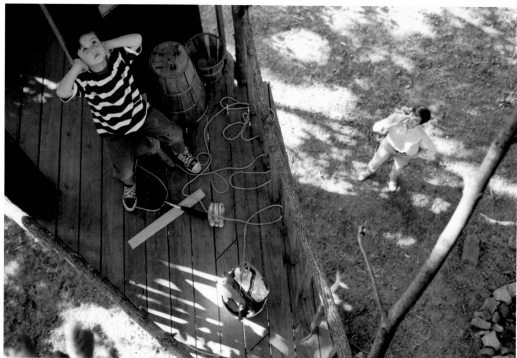

10 Change.

Fourth of July BBQ, Anytown, USA

What's red and white and changed all over?

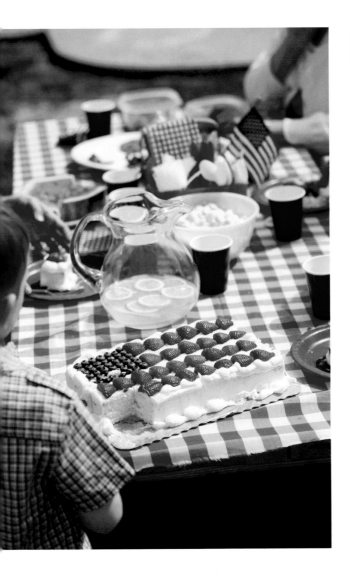
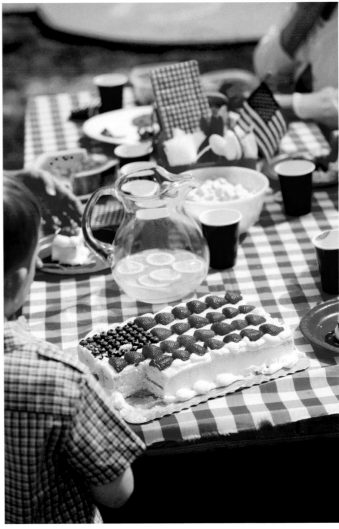

I Was Told There Would Be Cake

Frost these treats back together for a sprinkling of fun.

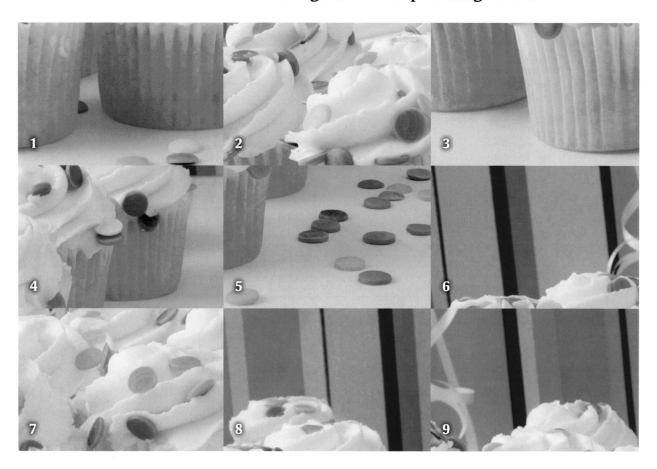

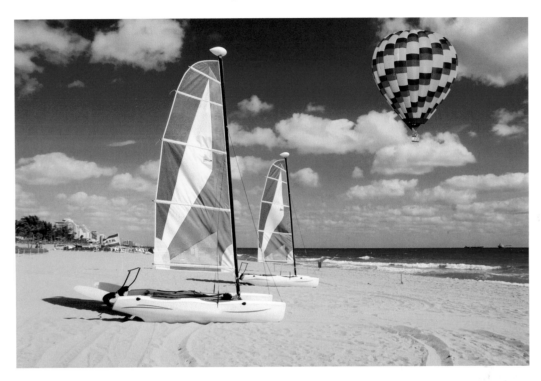

I'm Sailing Away . . .

. . . and I won't drop anchor until I spy changes.

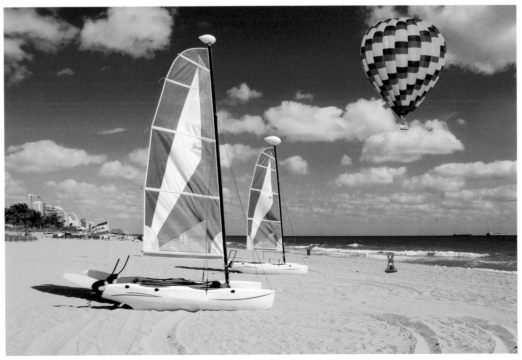

2 Changes

This One's No Picnic!

**Hope you brought extra snacks.
You're going to be here for a while.**

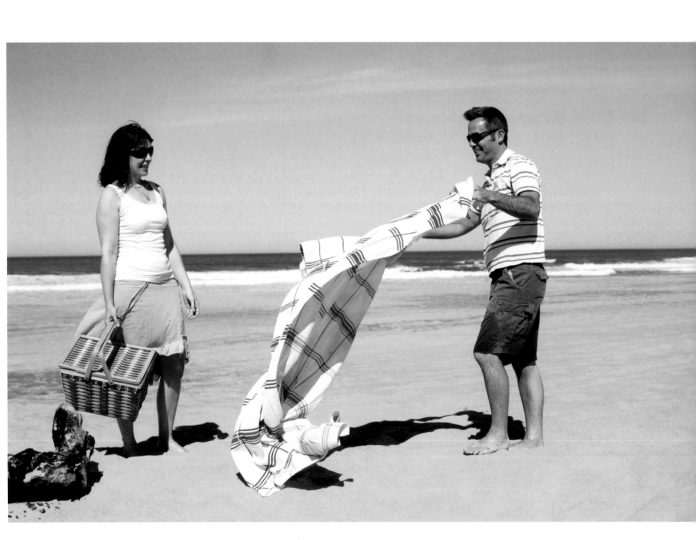

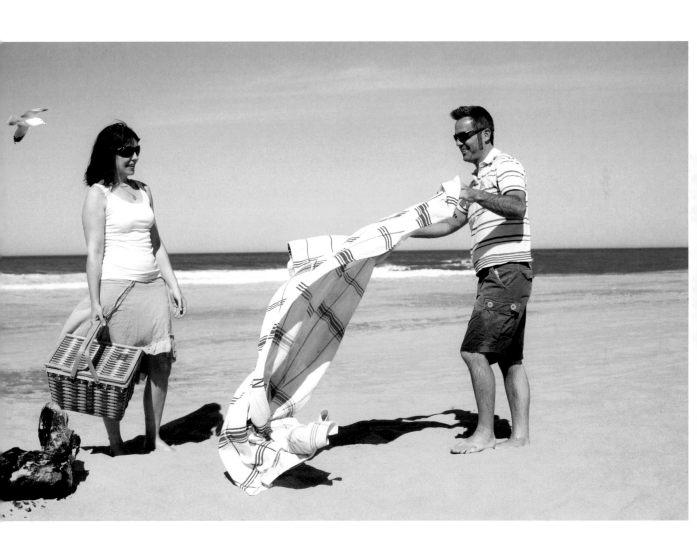

Future IRS Agents of America

They love it when they find an irregularity!
Quick! Find the ones in this puzzle before they do.

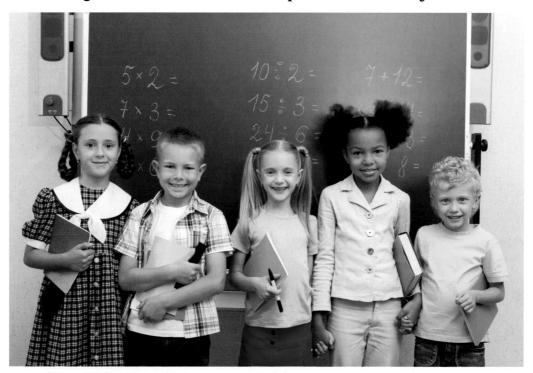

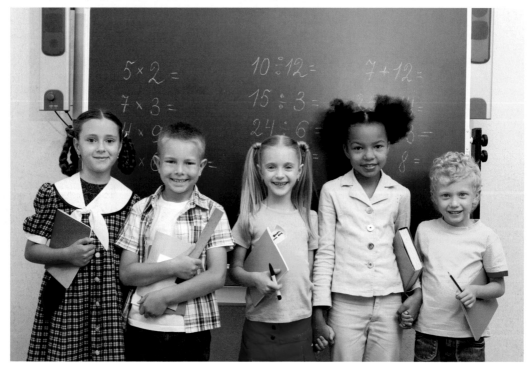

17 Change

Rush less and you're sure to find the image that's been altered.

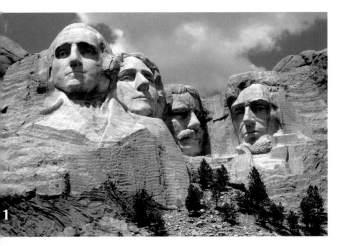

1

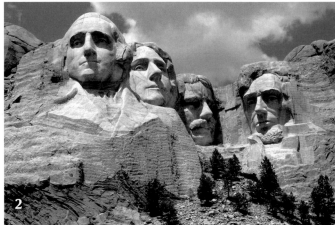

2

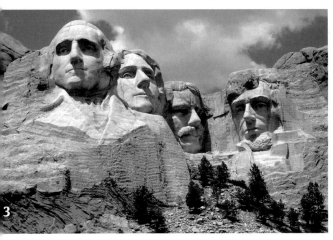

3

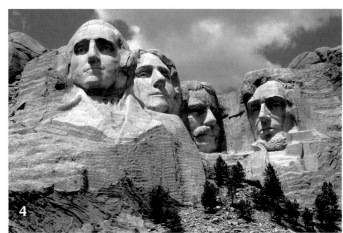

4

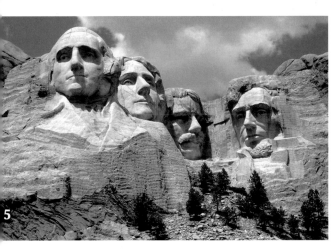

5

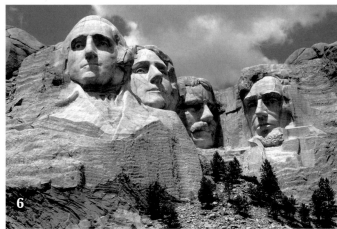

6

Rough Terrain

Take a Seat . . .

. . . outside the Capitol. Can you feel the change in the air?

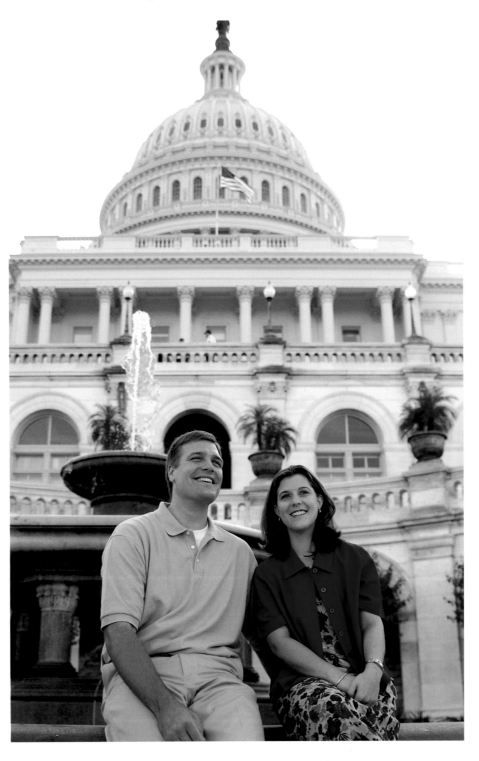

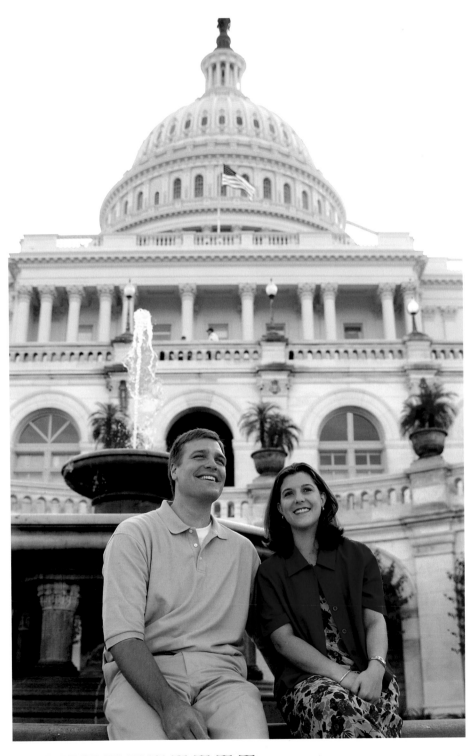

3 Changes

Rough Terrain

The Tail Wagon the Dog

Puppies, puppies everywhere, and only one set is different.

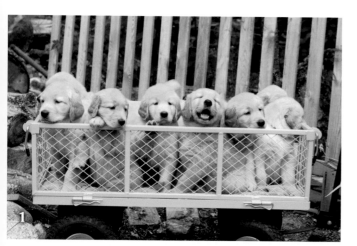

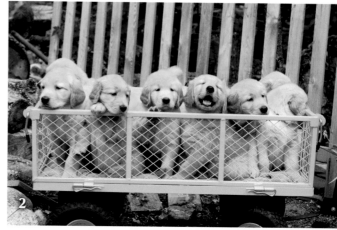

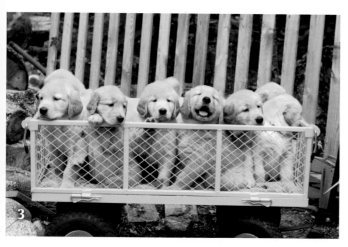

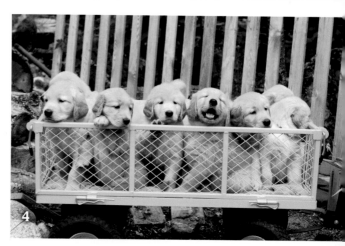

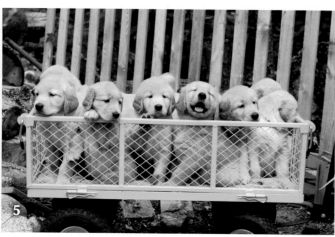

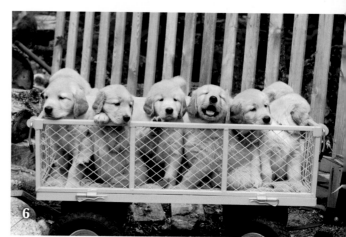

Will You Be Mine?

And then will you help me scrutinize these sweets?

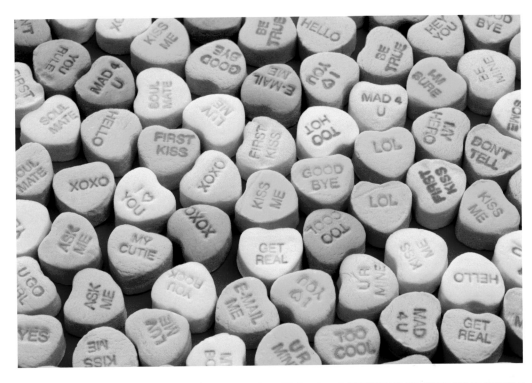

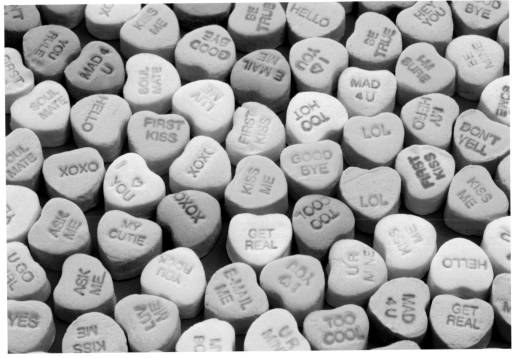

2 Changes ♡♡♡♡♡♡♡♡♡♡♡♡

Do Not Disturb

Power nappers of America unite!

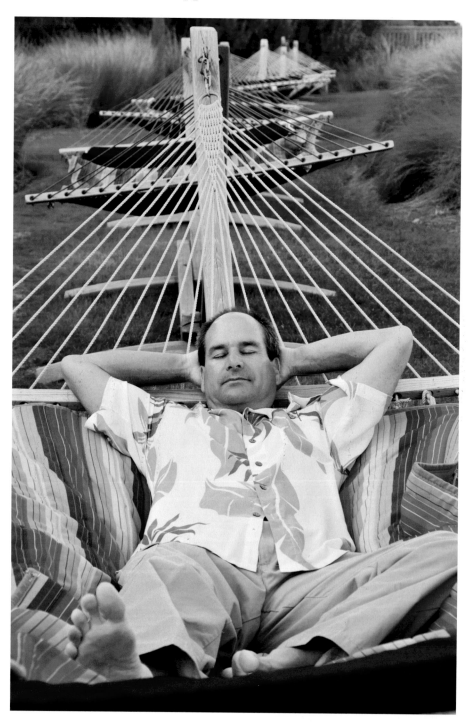

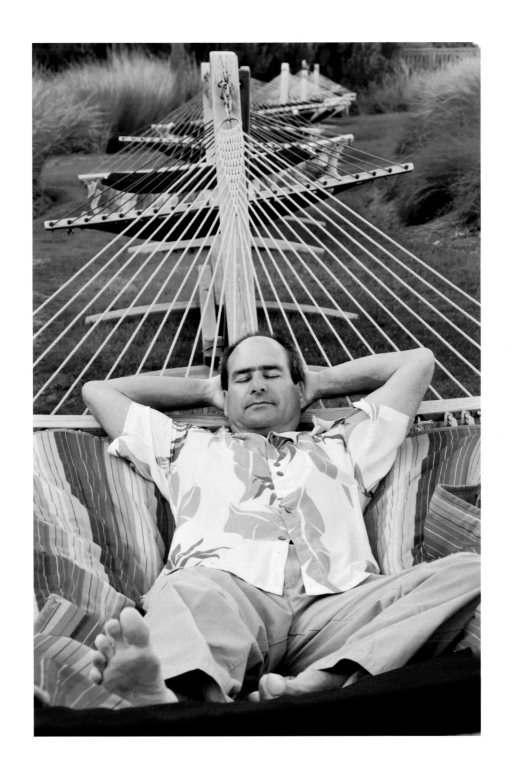

Target Practice

Are those toys safe?

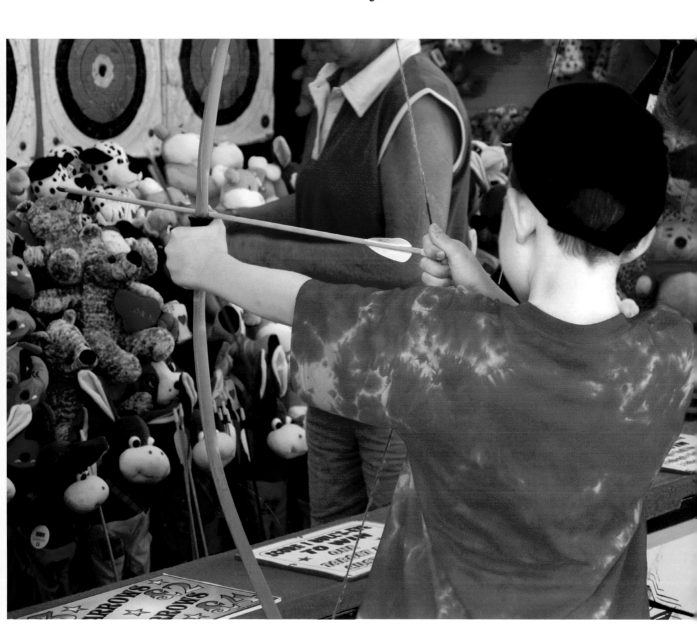

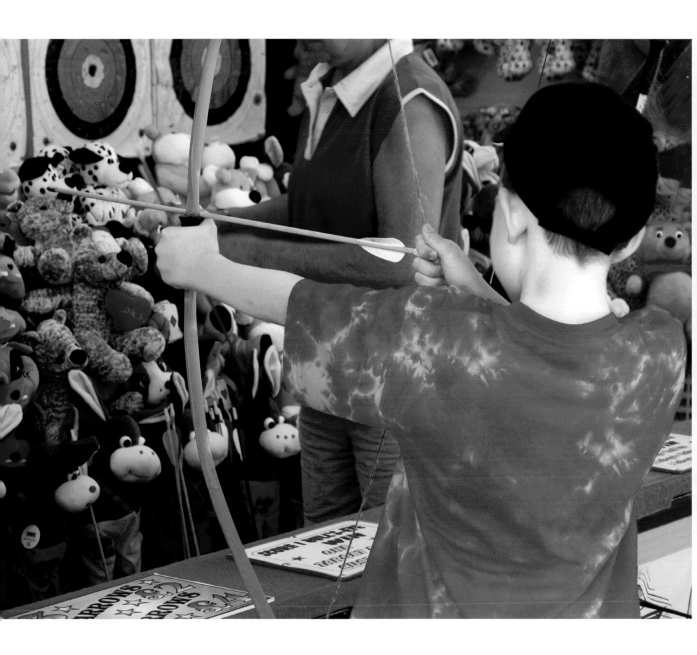

Lady Liberty

Give us your tired, your poor, your huddled masses yearning to be free of this dastardly puzzle.

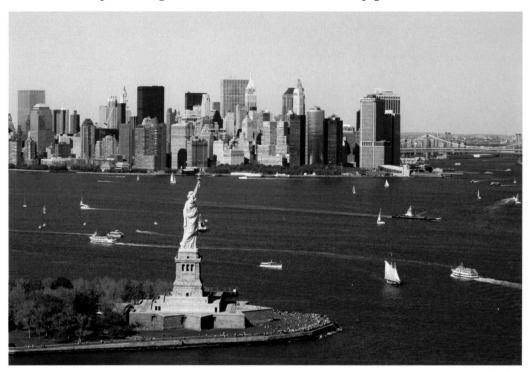

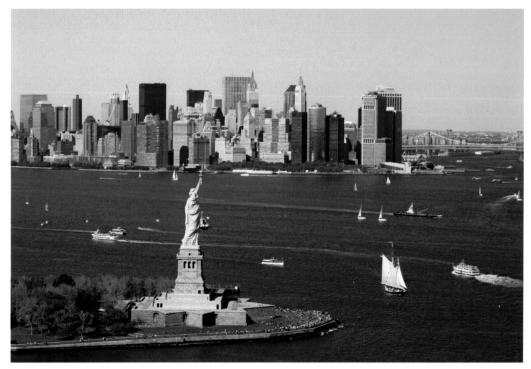

10 Change

And They're Off!

Bet big that you'll be able to track down what's different.

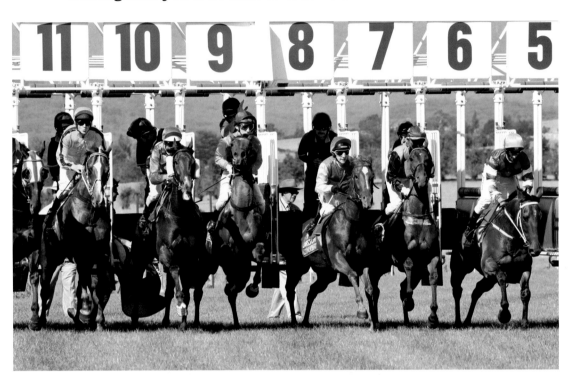

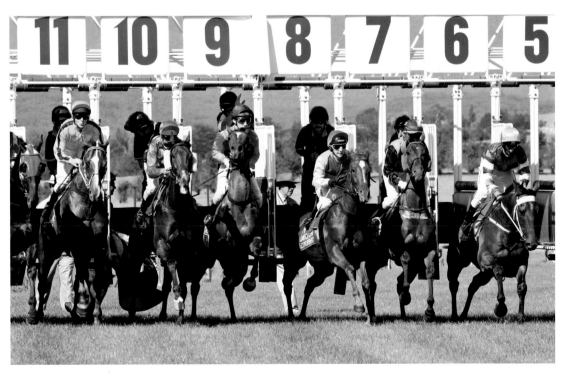

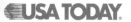

Traditional Dress

Put a feather in your cap when you've solved this puzzle.

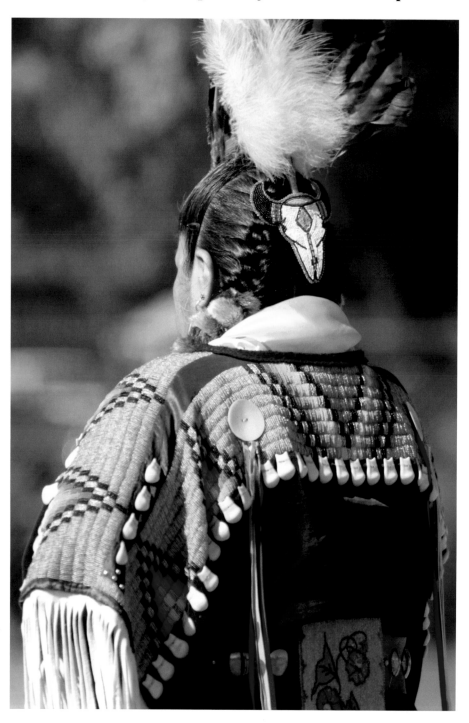

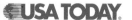

The Last Rest Stop

Who needs to go?
Who can find what's changed since the last time we stopped here?

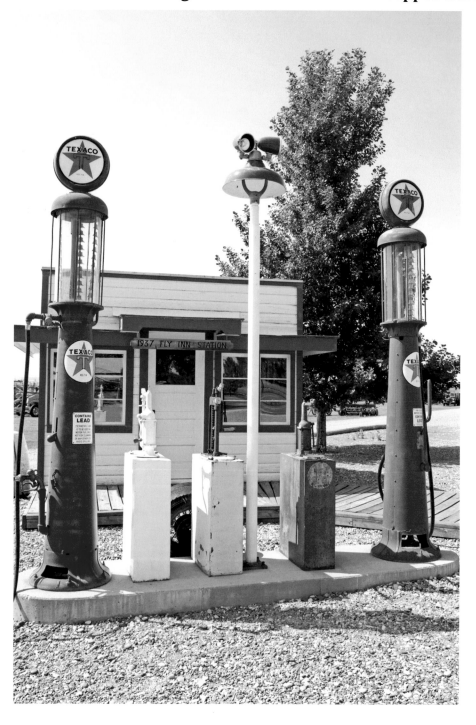

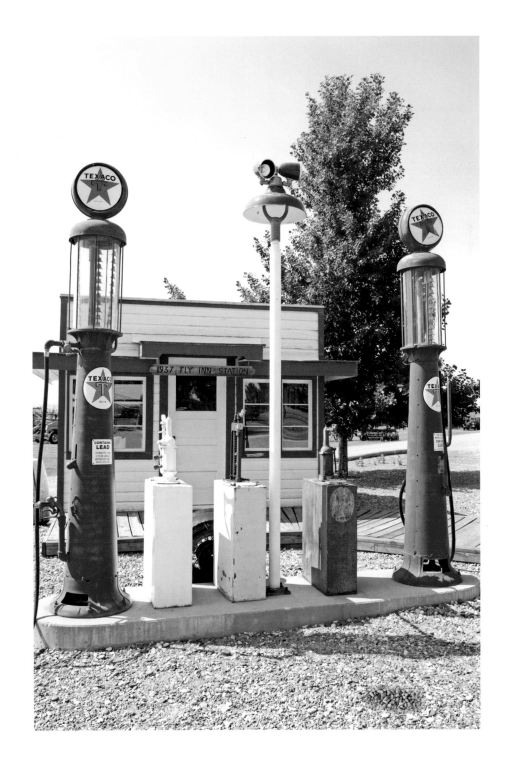

1937 FLY INN STATION

5 Changes ◡◡◡◡◡◡◡◡◡◡◡◡◡◡

Winter Wonderland

Barnstorm your way around the page to pinpoint the funny farm.

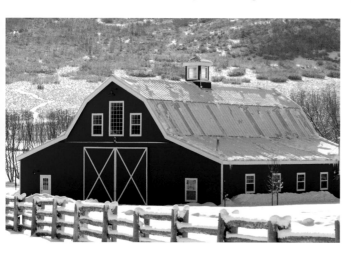

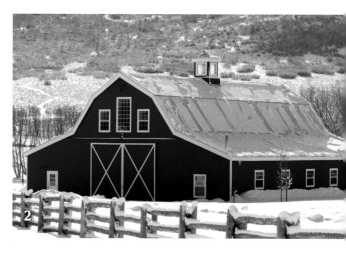

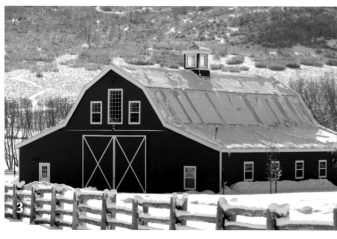

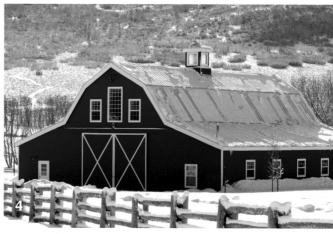

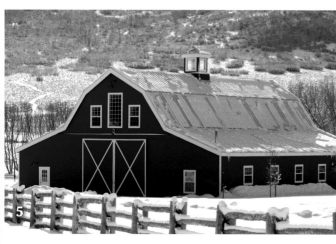

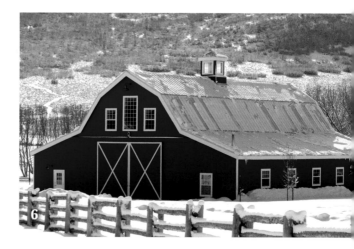

Souvenirs on the Half Shell

Don't be shell-shocked by the amount of time it takes to collect every unique item.

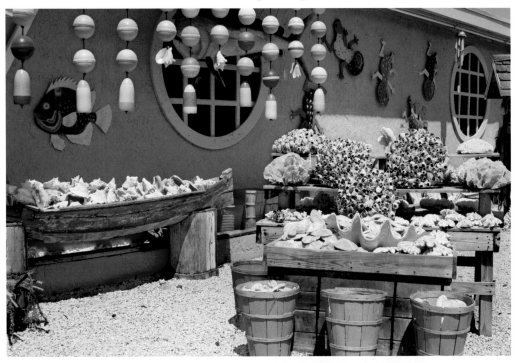

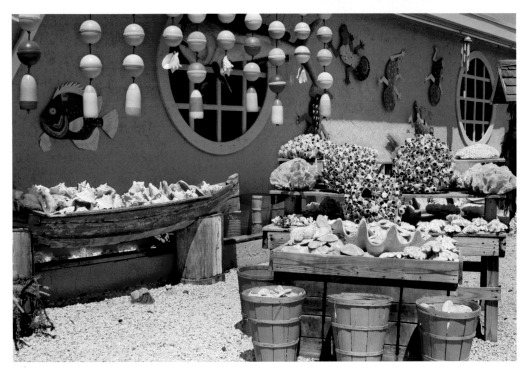

3 Changes

Rough Terrain

Medicine Man

**Whatever this guy is hawking,
you can bet the changes are patently ridiculous.**

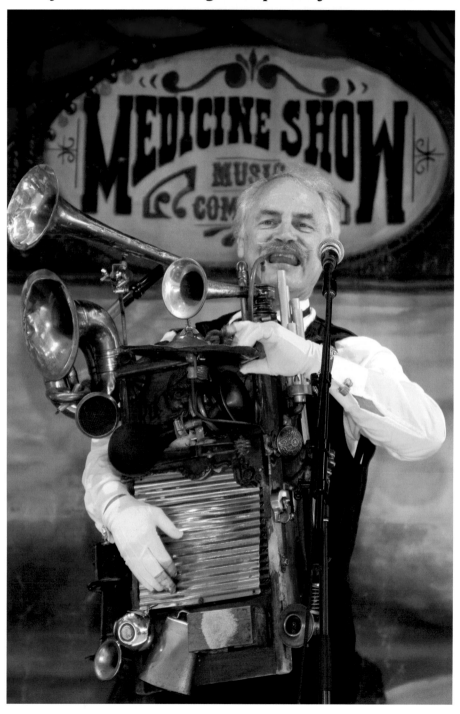

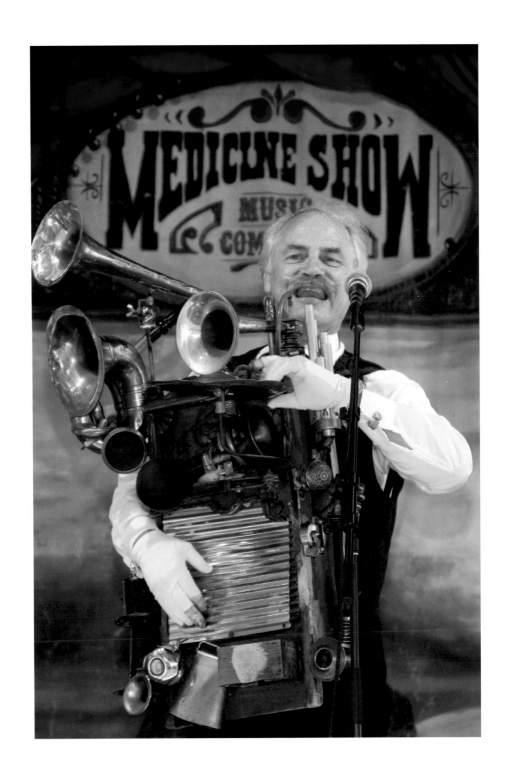

All Wrapped Up

Decorating the tree is one task that is never quite complete.

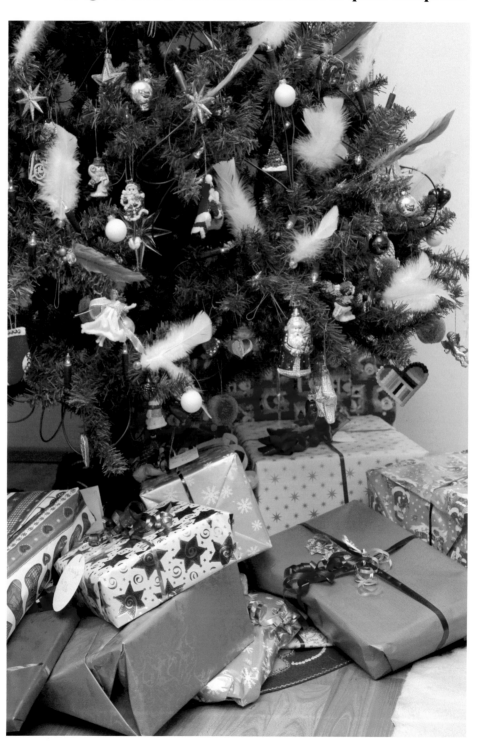

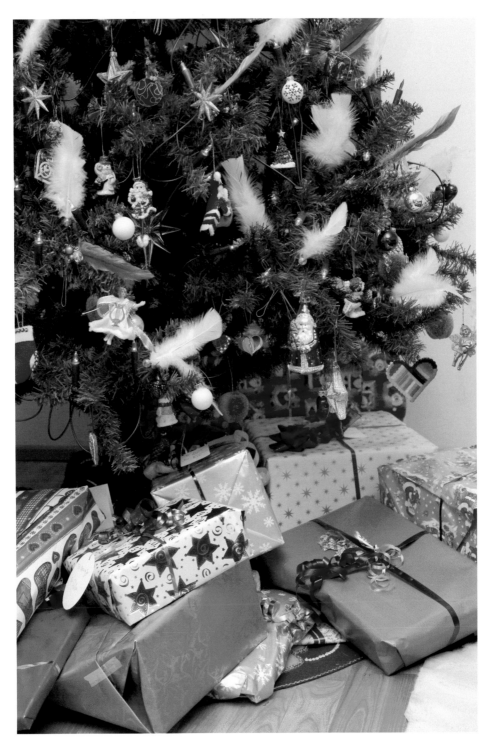

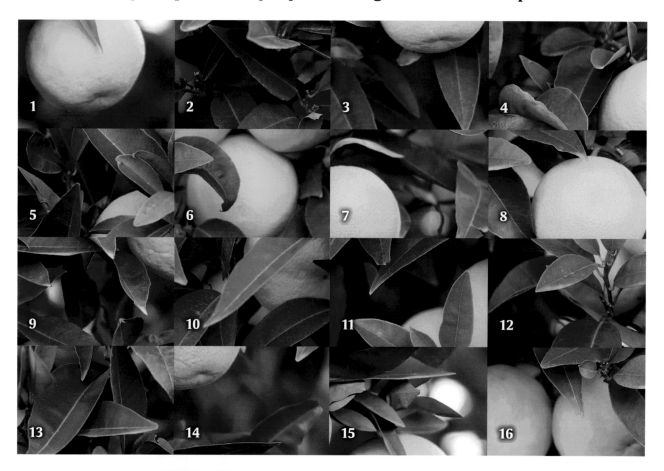

USA TODAY.

Florida's Finest

Can you squeeze this juicy "disarrangement" back into place?

Snail Mail

You won't get far with this collection.

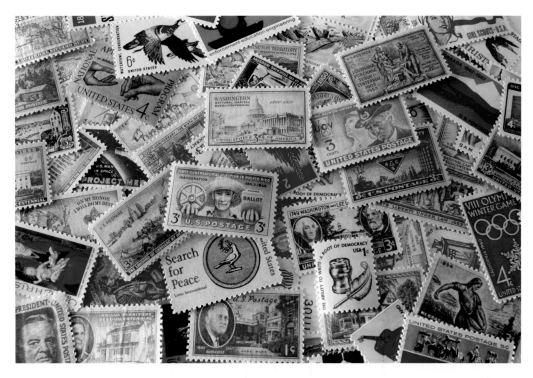

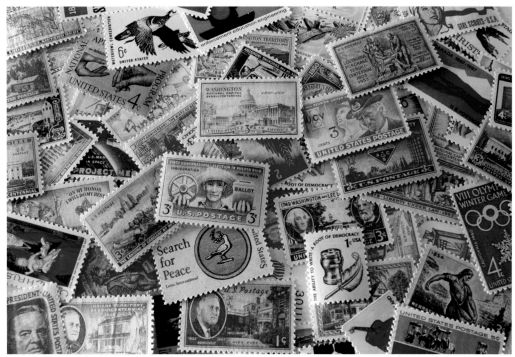

Horsin' Around

The neighs have it.

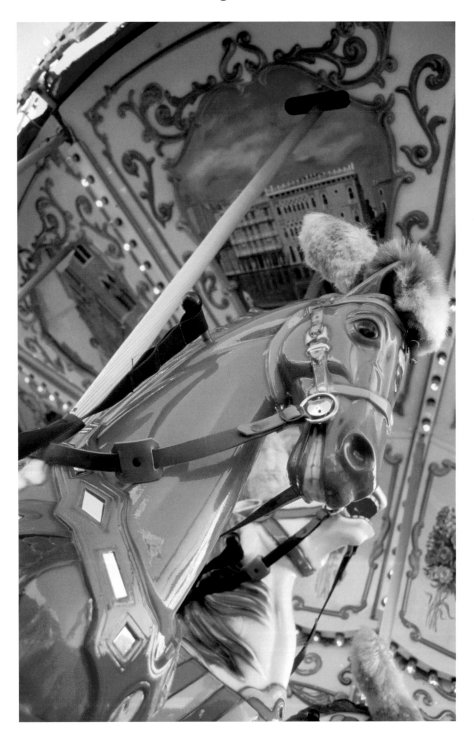

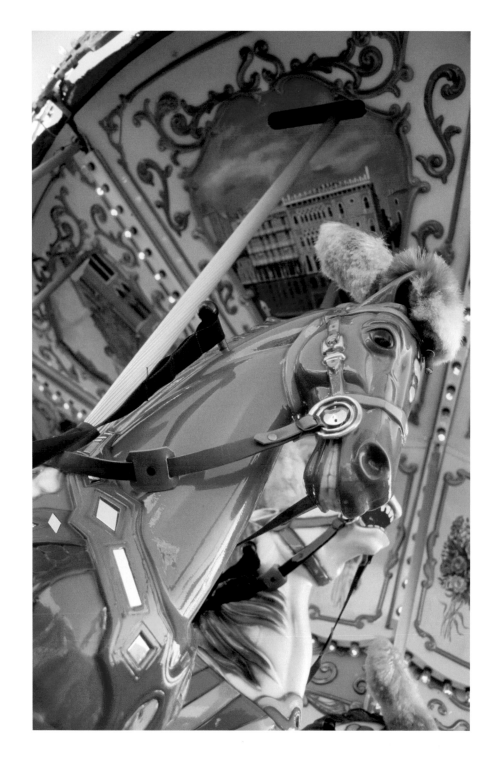

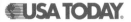

Put Your Best Foot Forward

**These boots were made for changing and that's just what they've done.
This tricky puzzle might just knock your socks off.**

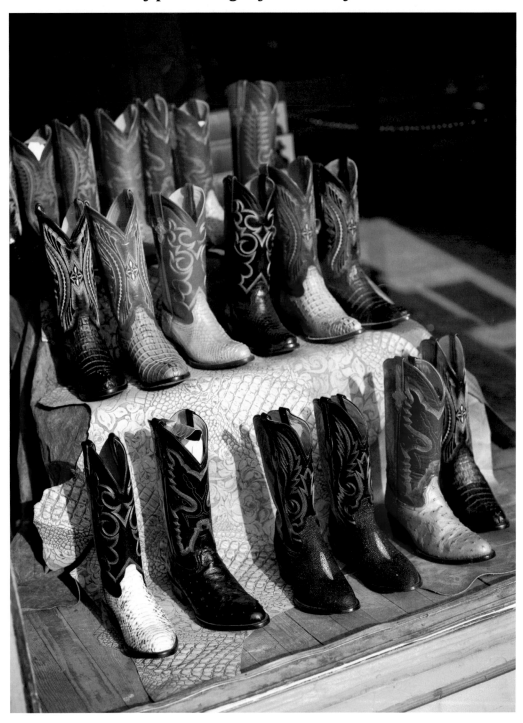

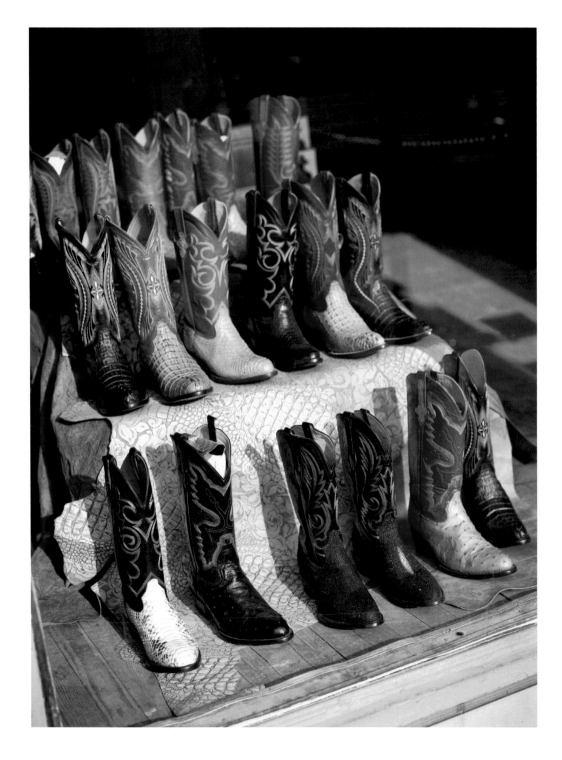

Birds of a Feather . . .

. . . may flock together, but they don't always stay put.
You'll need eagle eyes to pinpoint the picture that's unlike the rest.

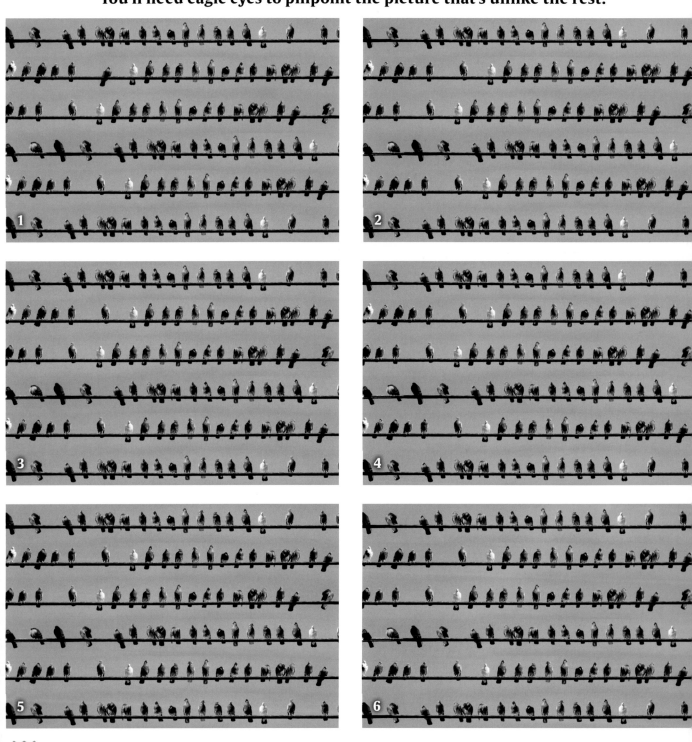

1 2 3 4 5 6

Neighborhood Yard Sale

**Welcome to the Bureau of Forgotten Furniture,
where one man's trash is another man's treasure.**

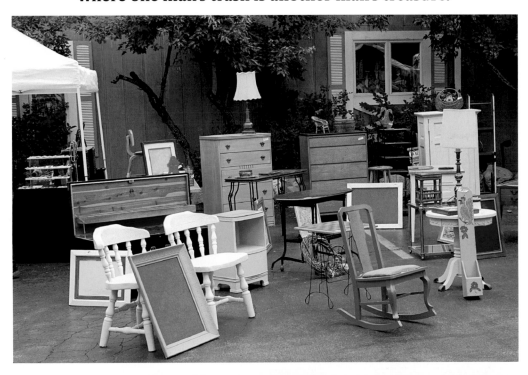

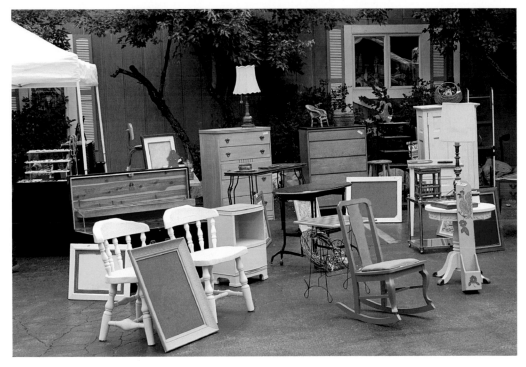

5 Changes ♡♡♡♡♡♡♡♡♡♡♡♡♡♡♡

Rough Terrain

Congratulations, Graduates!

**Inspect all the caps, peruse all the gowns,
and earn a degree in puzzle solving.**

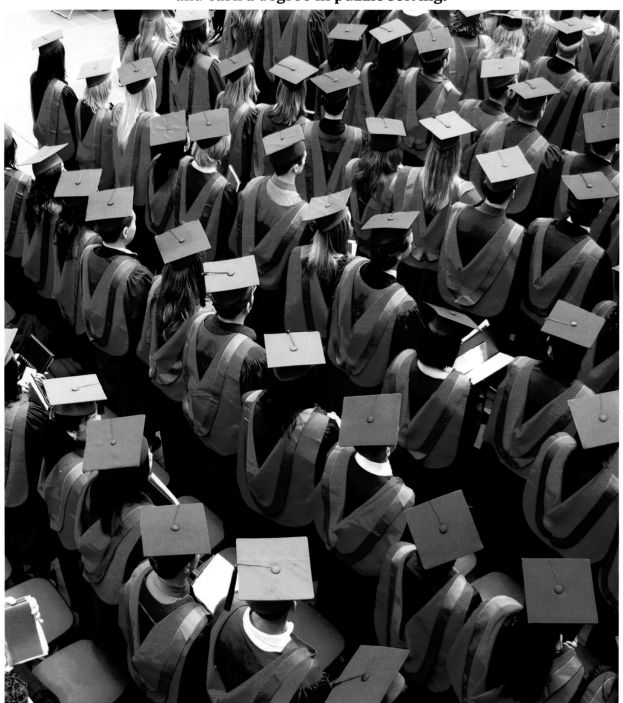

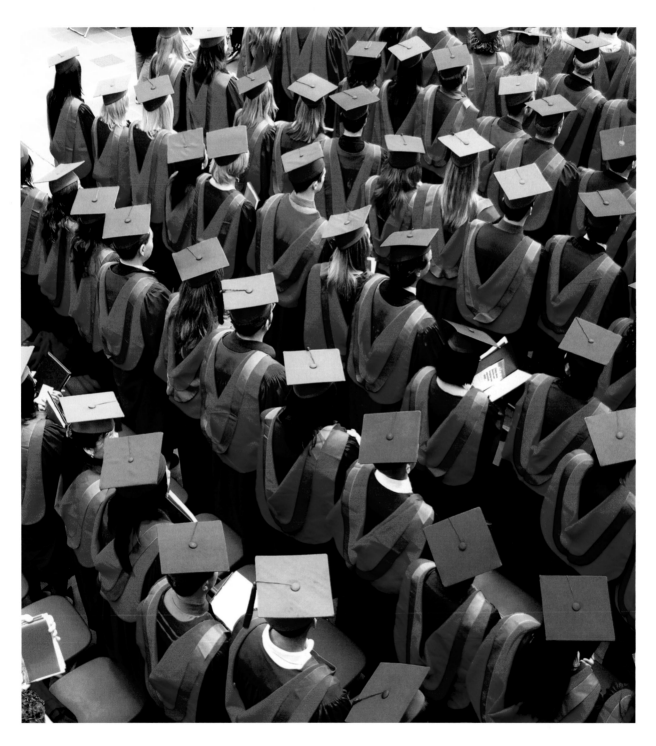

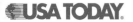USA TODAY.

The Crossroads of the World

New Yorkers never could stay put.

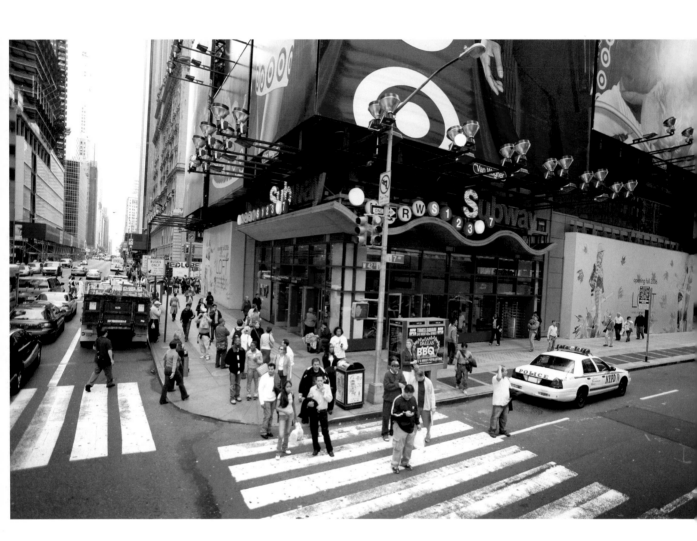

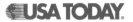

Toy Tangle

**These Wild West characters are all out of whack.
Can you put them back together again?**

Hard Hat Blues

Hope you get overtime for this one.

San Fran Celebration

Find the changes without leaving your heart there.

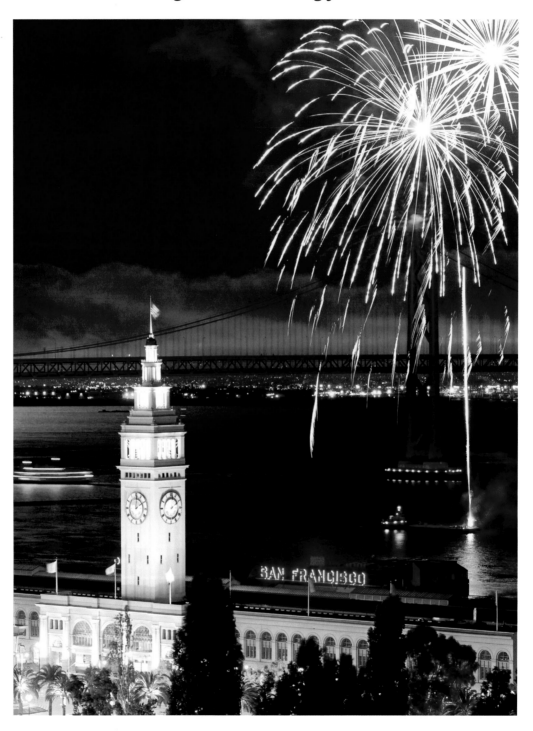

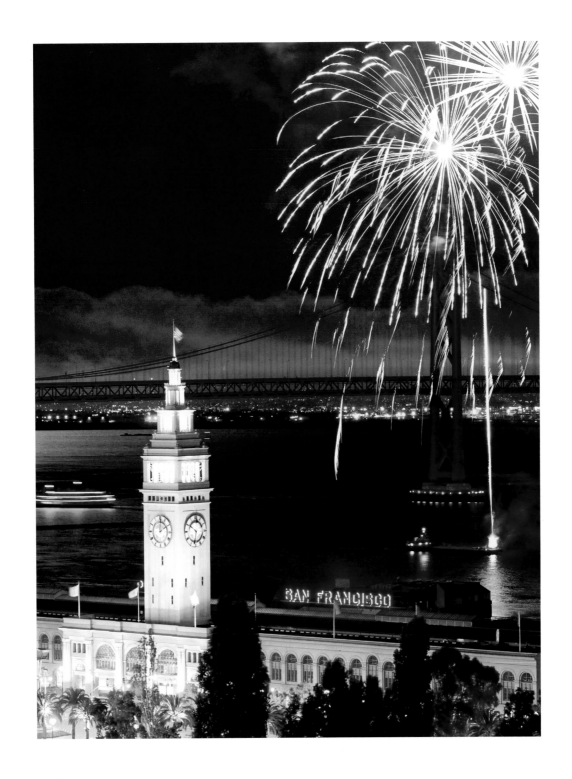

Candyland

Solve this puzzle before you turn into a pumpkin.

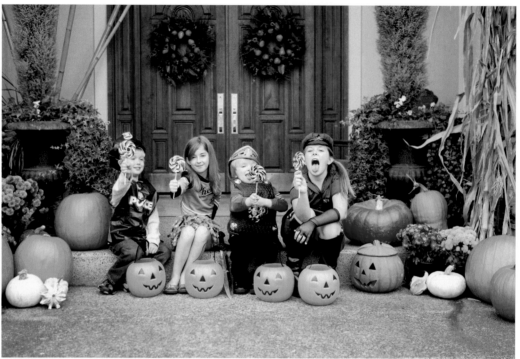

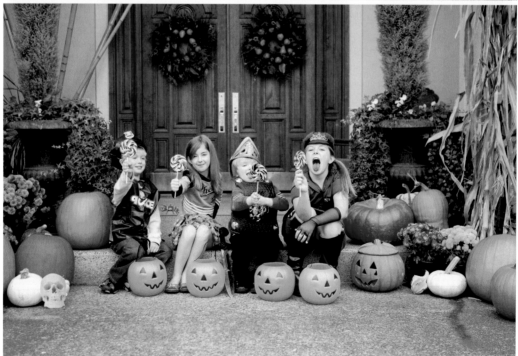

25 Changes

Sunny Daze

Re-create the flowery field below.

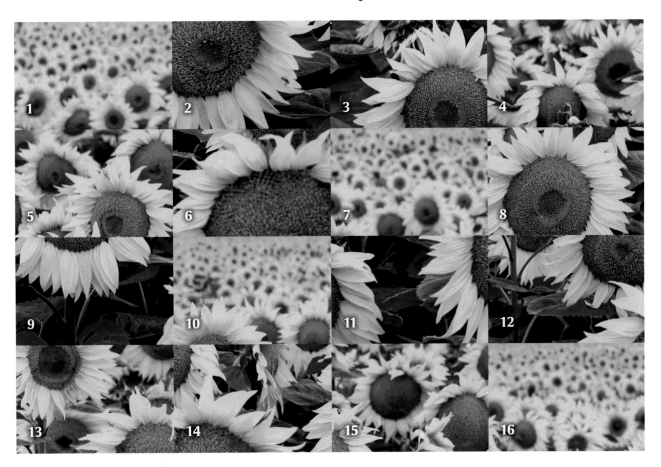

Aloha . . .

. . . means hello and good-bye in Hawaii!

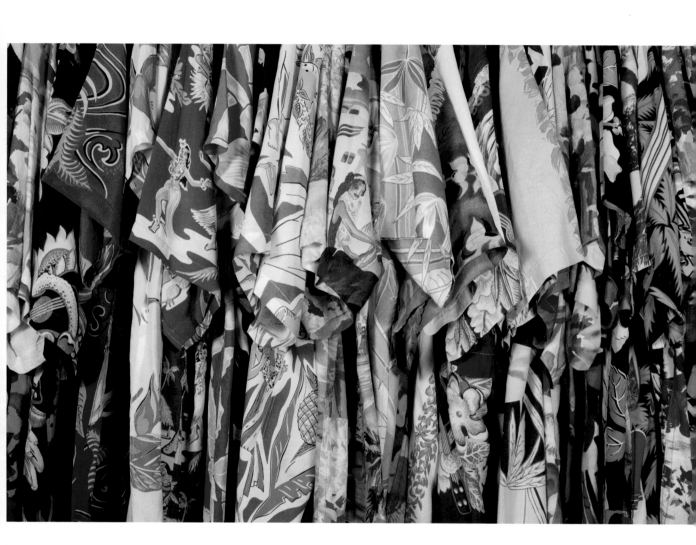

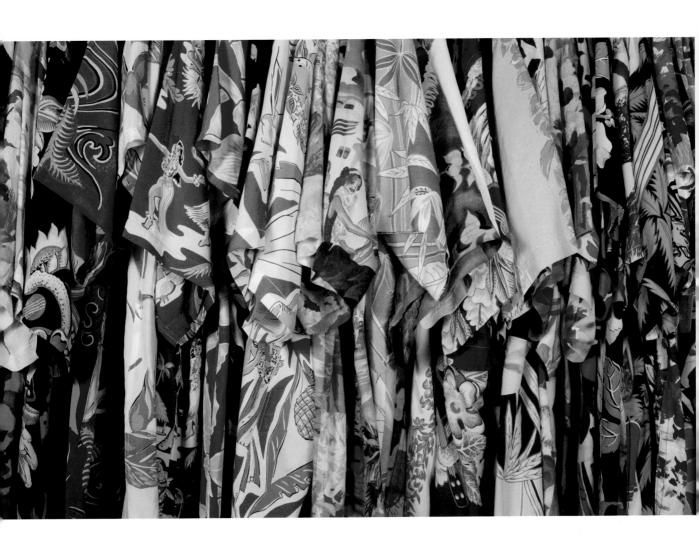

Solutions

Page 8

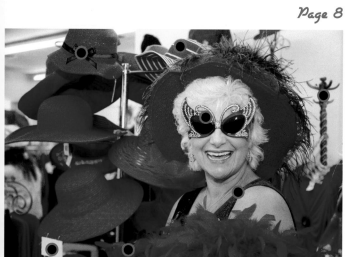

Page 9

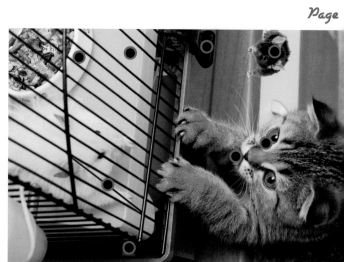

Page 10

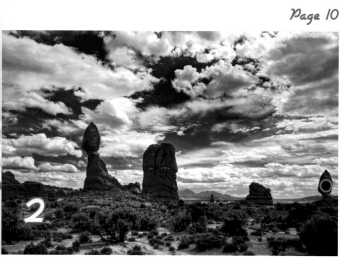

Page 11

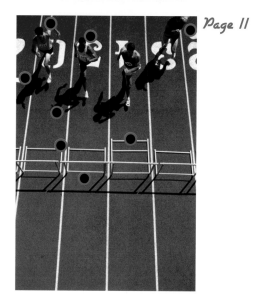

Page 12

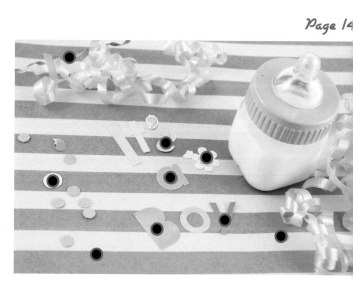

Page 14

Page 15

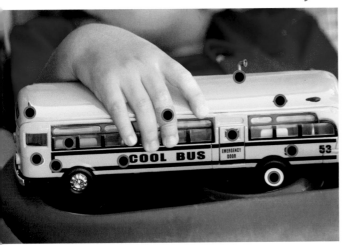

Page 16

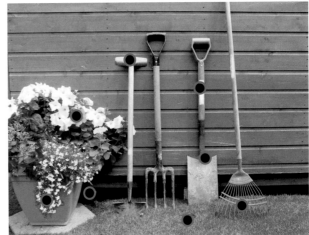

Page 17

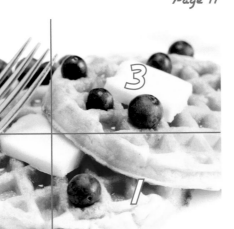

Page 18

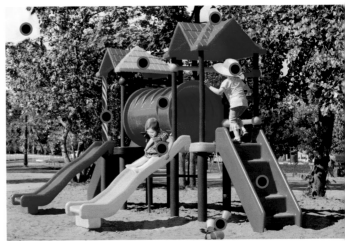

Page 20

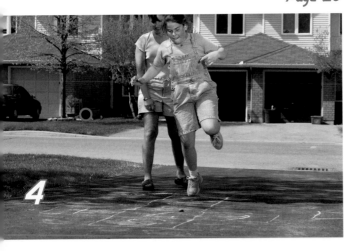

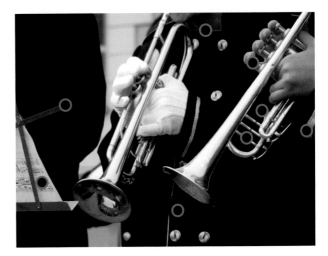

Page 21

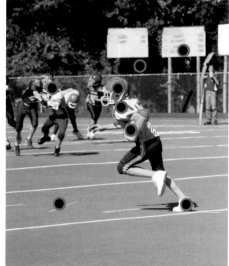

Page 22

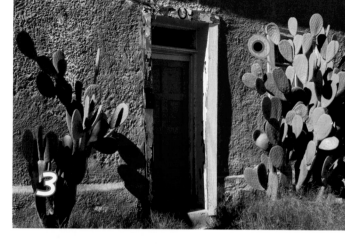

Page 2

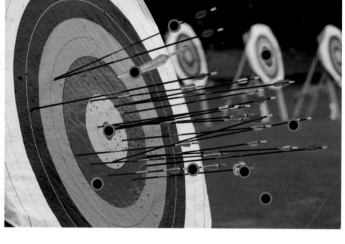

Page 25

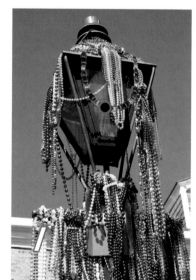

Page 26

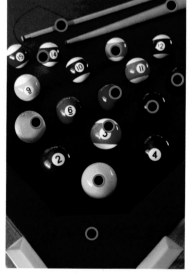

Page 28

Page 27

Solutions

Page 30

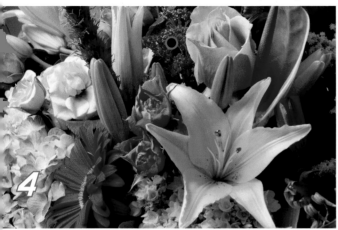

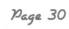

Page 31

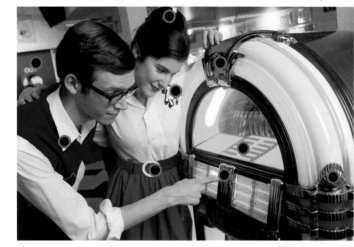

Page 32

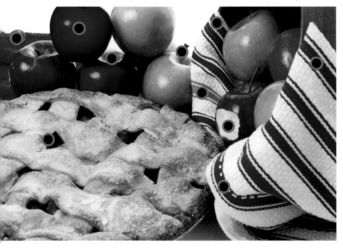

Page 33

Page 34

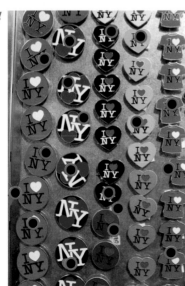

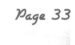

Page 36

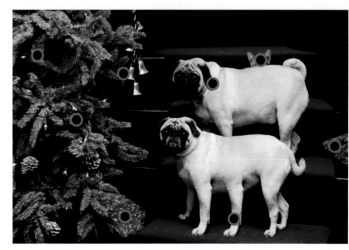

Page 37

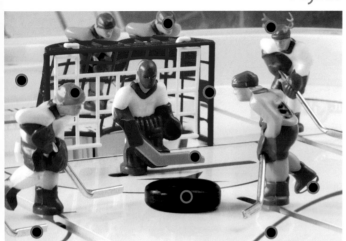

Page 40

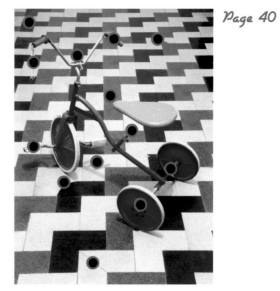

Page 42

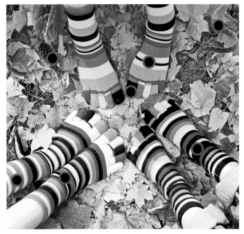

Page 4.

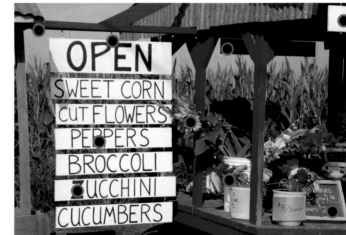

OPEN
SWEET CORN
CUT FLOWERS
PEPPERS
BROCCOLI
ZUCCHINI
CUCUMBERS

Page 4.

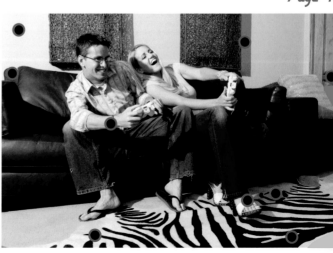

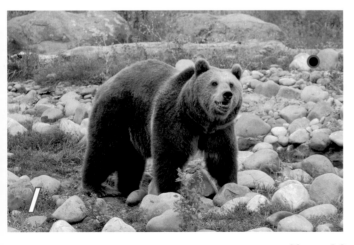

Page 44

Page 46

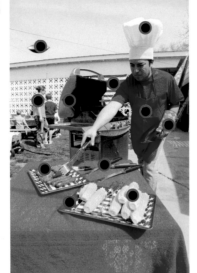

Page 48

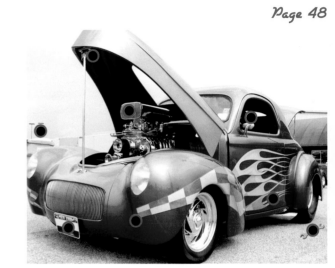

Page 49

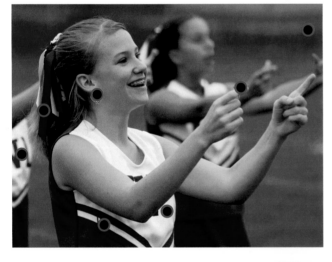

Page 50

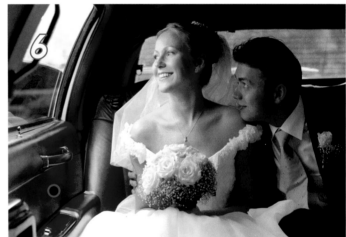

Page 52

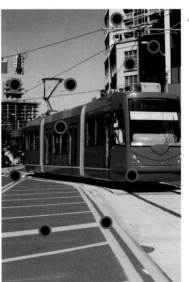

Page 51

USA TODAY

Page 54

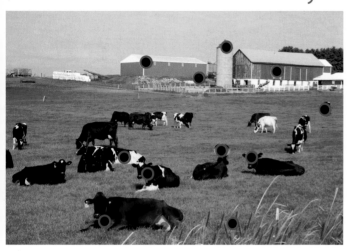

Page 5

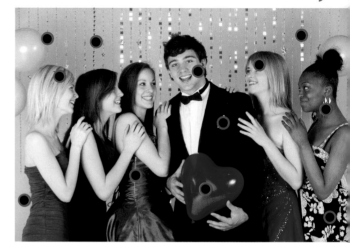

Page 56

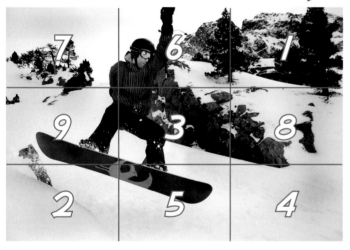

Page 57

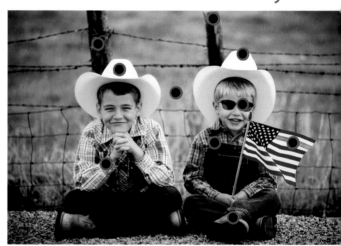

Page 60

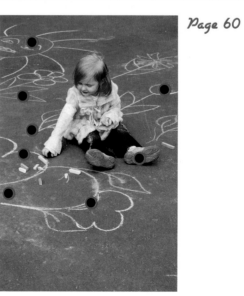

Page 58

Page 62

Page 63

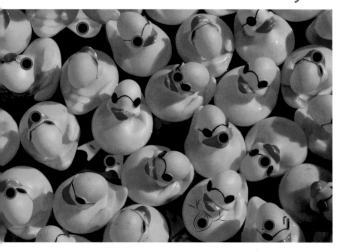

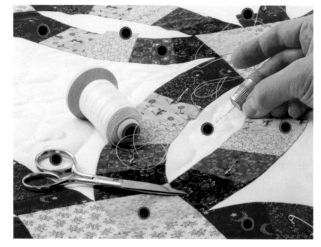

Page 64

Page 66

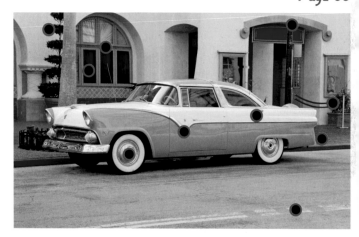

Page 67

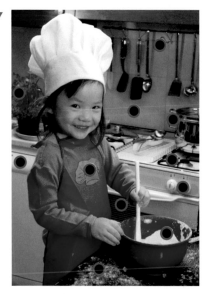

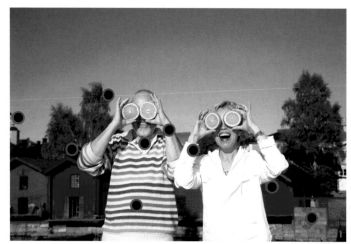

Page 68

Page 69

Page 70

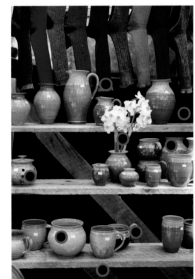

Page 72

Page 73

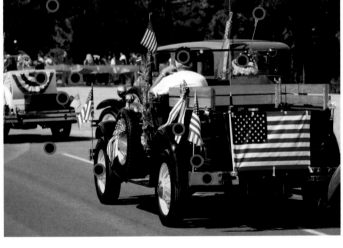

Page 74

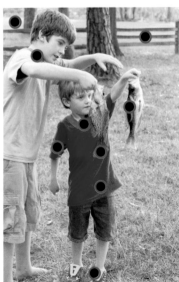

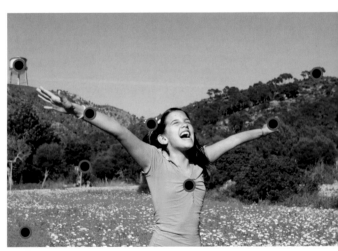

Page 75

Page 76

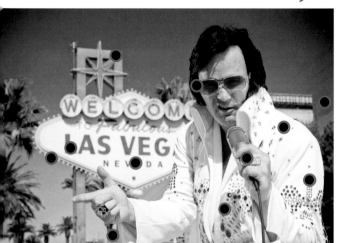

Page 77

Page 78

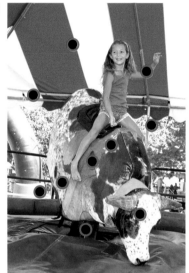

Page 80

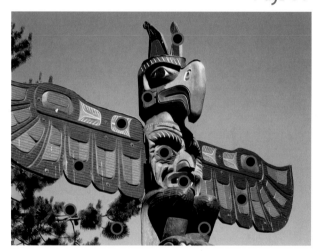

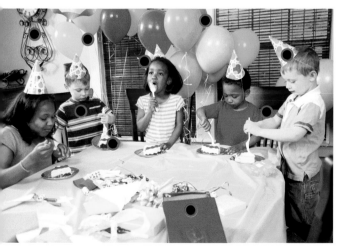

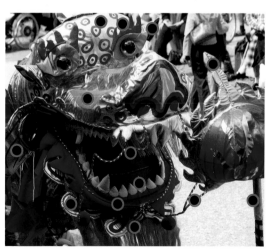

Page 81 Page 82

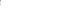
Page 84

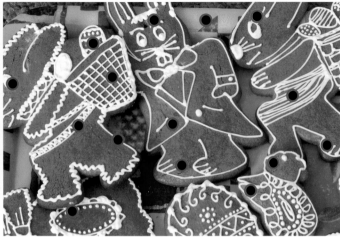

Page 8

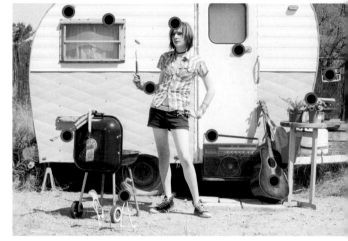

Page 86

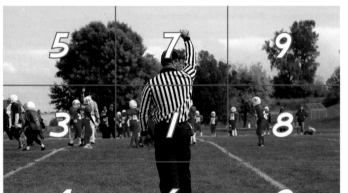

5 7 9

3 1 8

4 6 2

Page 8

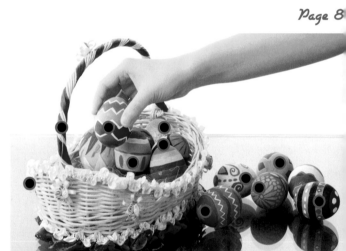

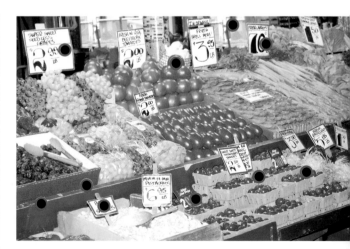

Page 88

Page 8

Page 90

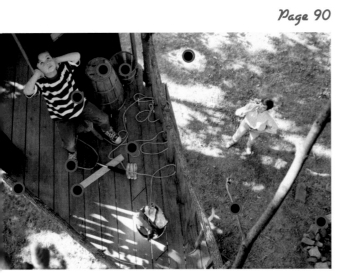

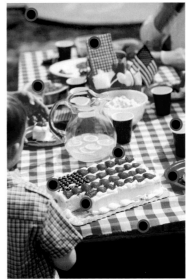

Page 91

Page 92

Page 93

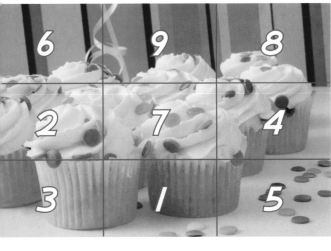

6 9 8

2 7 4

3 1 5

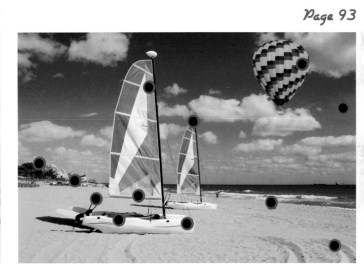

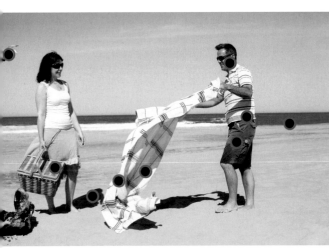

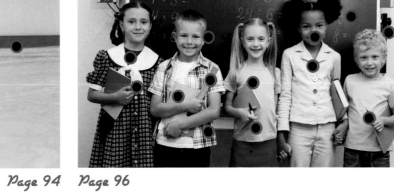

Page 94 *Page 96*

Page 97

Page 100

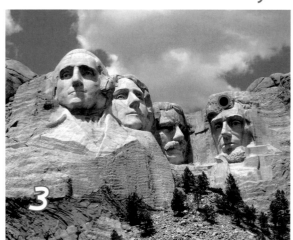

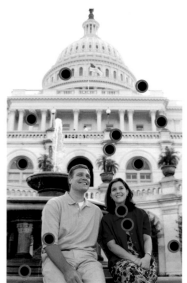

Page 102

Page 10

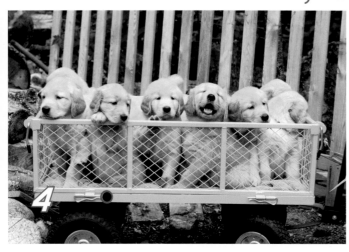

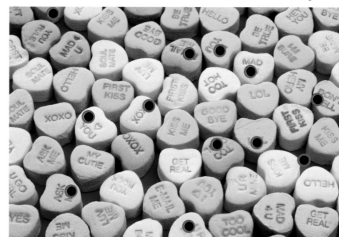

Page 104

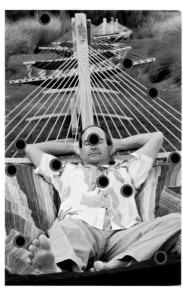

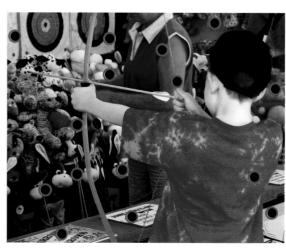

Page 106

Page 108

Page 109

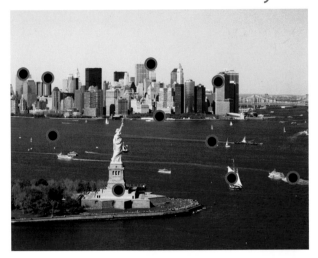

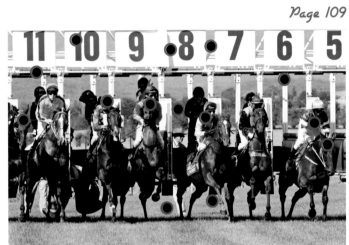

Page 110

Page 112

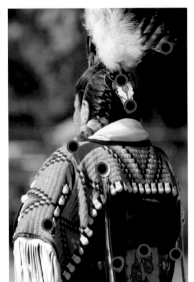

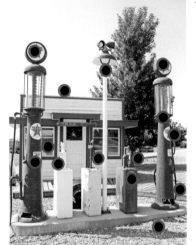

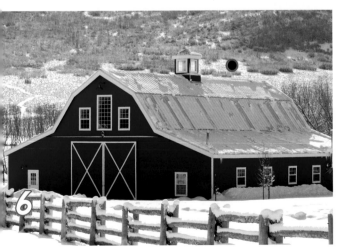

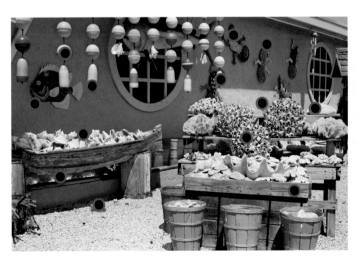

Page 114 Page 115

USA TODAY

Page 116
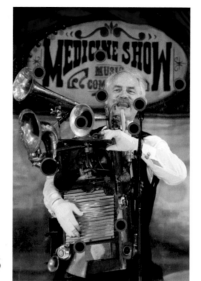

Page 118
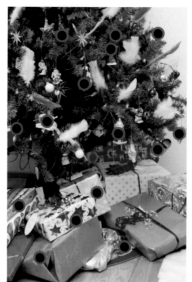

Page 120
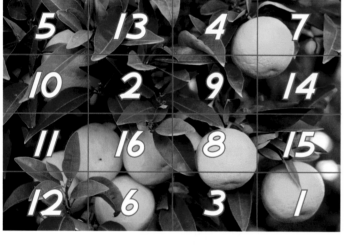

5	13	4	7
10	2	9	14
11	16	8	15
12	6	3	1

Page 1
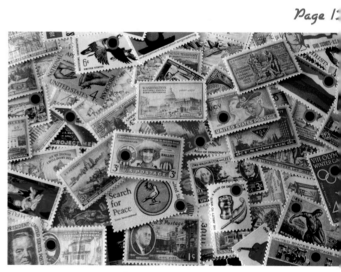

Page 122
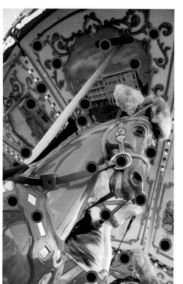

Page 124
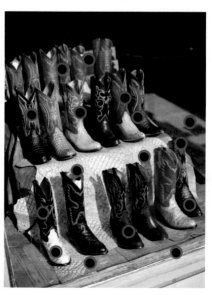

Page 127

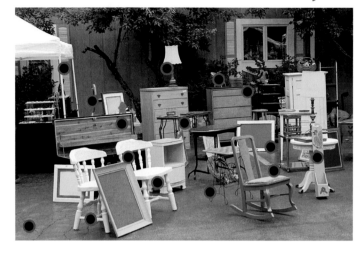

Page 126

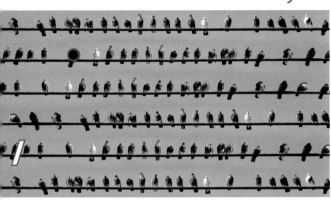

Page 128

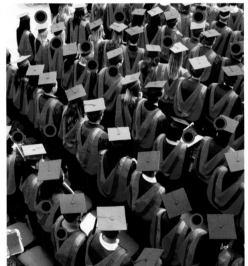

Page 130

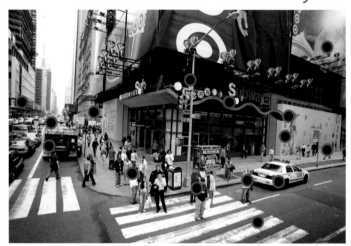

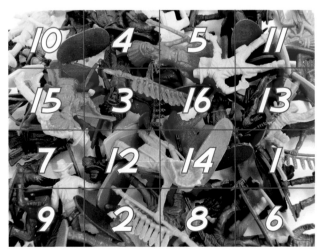

Page 132 Page 133

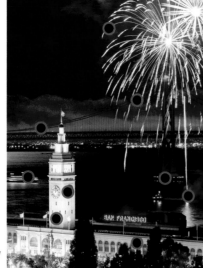

Page 134

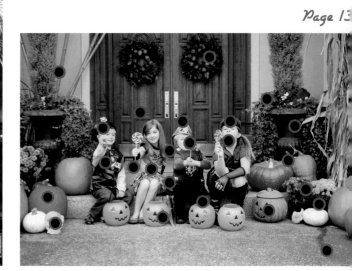

Page 13

Page 137

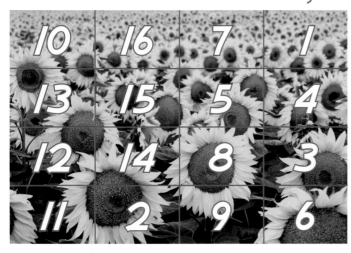

10 16 7 1
13 15 5 4
12 14 8 3
11 2 9 6

Page 13

Photo Credits